CONTEMPORARY

OUTDOOR

SCULPTURE

ROCKPORT

CONTEMPORARY

OUTDOOR

SCULPTURE

BROOKE BARRIE • INTRODUCTION BY GLENN HARPER

GLOUCESTER MASSACHUSETTS

ROCKPORT PUBLISHERS

First published in the United States of America by:
Rockport Publishers, Inc.
33 Commercial Street
Gloucester, Massachusetts 01930-5089
Telephone: (978) 282-9590
Facsimile: (978) 283-2742

Distributed to the book trade and art trade in
the United States by:
North Light Books, an imprint of
F & W Publications
1507 Dana Avenue
Cincinnati, Ohio 45207
Telephone: (800) 289-0963

Other Distribution by:
Rockport Publishers, Inc.
Gloucester, Massachusetts 01930-5089

ISBN 1-56496-421-3
10 9 8 7 6 5 4 3 2 1
Design: Fahrenheit
Front Cover Image: Dennis Oppenheim (page 117)
Back Cover Images: *top,* Strong-Cuevas (page 141);
middle, Audrey Flack; *bottom,* Alexander Liberman
(page 95)
Printed in China.

Many thanks to Bruce Petronio for his research assistance, and to the artists, whose generosity and cooperation made this book a reality.

PREFACE

When I was first contacted by Rockport Publishers to submit a proposal to author *Contemporary Outdoor Sculpture*, I thought that choosing approximately forty sculptors to include in the book would not be too difficult. I soon found out that I was mistaken. My initial list of artists contained 185 names. Working from the assumption that some of the artists would not be able to participate, letters were sent to 85 sculptors in the hopes that about half would respond with suitable visual materials.

Paring down the list to 85 was far from easy. There were plenty of considerations to take into account: I wanted to include living artists who had done a number of outdoor works, with those works placed in many different types of settings: urban areas, gardens, parks, and other natural environments. I also wanted to illustrate international sites. Finally, I wanted to incorporate examples of all facets of contemporary outdoor sculpture—representational, abstract, site-specific, and, if possible, more ephemeral works. The highest caliber sculptures were selected from those submitted, in terms of both sculpture and image quality.

With relatively few titles in existence on the subject, my research took me to the Internet, to the past ten years of *Sculpture* magazine, (the "Site" and "Commissions" features were especially helpful), to the files and slide registry I have amassed as the director of a sculpture park and museum, and finally, to artists, curators, and enthusiasts, whose suggestions turned up artists I might otherwise have missed.

Outdoor sculpture exists in many different situations: sculpture parks and gardens, institutional collections such as at museums and universities, and private and corporate collections. Its presence is growing. The International Sculpture Center in Washington, D.C. noted a more than 100% increase in the number of sculpture parks and gardens between 1987 and 1996, from 97 to 195. These numbers reflect a growing interest in outdoor sculpture which continues today. Not only are new venues coming into being, but older institutions are expanding their spaces and moving outdoors.

In the following pages you'll find a thorough look at contemporary outdoor sculpture, concentrating on prominent living artists with significant reputations in the field, but also including younger, less established sculptors who are doing important work. It is a celebration of outdoor sculpture. I hope the reader finds as much enjoyment in the discovery of new artists and new outdoor sculpture as I have.

Brooke Barrie

CONTEMPORARY OUTDOOR SCULPTURE

The term *outdoor sculpture* is the most inclusive way to describe the form of art that is most completely at home in our own world, that exists among us in our public life. Since the significance of the word *public* is currently hotly contested, speaking of outdoor sculpture rather than public art has distinct advantages. In the context of *public art*, the artist is often expected to be a deferential junior partner in a bureaucratic or administrative process that smothers original and provocative sculpture.

The energy and spirit that is sometimes difficult to achieve in public art has shifted in some cases toward other, less bureaucratic, venues. Sculpture parks, for example, have become places where new ideas can be tried out—new relationships with audiences as well as new approaches to sculpture. These facilities for contemporary outdoor sculpture are sometimes adjuncts to contemporary art institutions (such as the Walker Art Center in Minneapolis), sometimes independent facilities (such as Storm King Art Center or Socrates Sculpture Park), and sometimes affiliated with institutions that have multiple educational, exhibition, and production functions (such as Grounds For Sculpture). The Neuberger Museum has recently instituted a biennial exhibition of public art, exhibited on the grounds of the State University of New York, Purchase, and other universities, notably the University of California, San Diego, have created important sculpture parks and gardens. A sculpture park is marked off as an enclave within the public arena, and the tastes, expectations, and politics of the everyday can be set aside in this border zone in favor of experimentation, exploration, and innovation. The work shown in and created for sculpture parks demonstrates that sculptors continue to make an invaluable contribution to our culture and our lives, even in this oversaturated era of media culture. Many of the artists whose work is shown in the following pages are contributors to the sculpture parks and gardens that are increasingly important to the field of sculpture, as well as to the preservation and advancement of cultural life in the contemporary world.

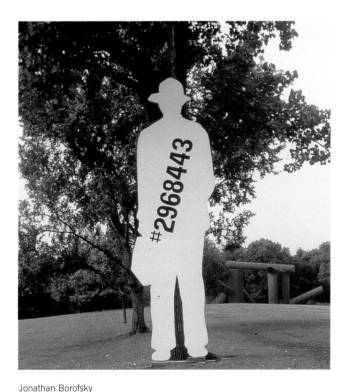

Jonathan Borofsky
Man with Briefcase at 2,968,443
epoxy enamel on fiberglass
24' x 7' x 1" (.6 m x 2.1 m x 2.5 cm)
Laumeier Sculpture Park, St. Louis, Missouri

The sculptors included in this volume vary widely in their approach to outdoor sculpture and in the placement of their work within the public sphere. Some of these artists achieve powerful results by challenging conventional notions of the sculptural object. Alan Sonfist and Mary Miss have, in different ways, achieved environments of great subtlety and complexity. Athena Tacha and Michele Oka Doner have managed to maintain high standards of artistic achievement in projects that become enlivening spaces for daily life. Tom Otterness and Dennis Oppenheim have established a playful spirit and a direct public address that brings overt wit and intelligence into the public arena.

J. Seward Johnson, Jr. creates work that approaches us in the most direct and intimate way. His realistic bronze figures are us, and we often encounter them in the street, in the context of our daily lives. Audrey Flack's sculpture is simultaneously highly realistic and explicitly allegorical, and is often located in highly significant civic sites. Deborah Butterfield, Jonathan Borofsky, and Fernando Botero have, in very different ways, established signature forms that are readily appreciated by the public, yet retain an undeniable sophistication and aesthetic power in the urban context where they are often sited. Luis Jiménez and Viola Frey also make sculpture that is highly approachable, but their realistic figures operate at the boundary between popular culture, ethnic identity, daily life, and aesthetic process.

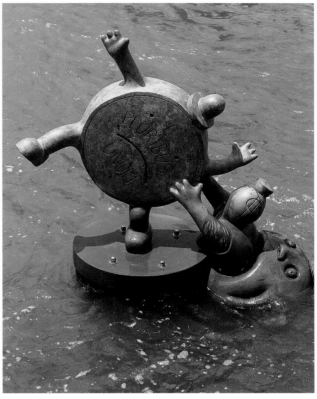

Tom Otterness
Marriage of Real Estate and Money, detail
cast bronze
Roosevelt Island, New York, New York,
 Commissioned by the Roosevelt Island
 Operating Commission
Courtesy of Tom Otterness and Marlborough
 Gallery, New York
 © Tom Otterness, 1996
photo: Oren Slor

Other featured sculptors have made essential contributions to the visual, aesthetic character of public space. Arnaldo Pomodoro, Robert Murray, and Clement Meadmore have created highly recognizable sculptural forms that have become essential elements of our urban landscape. Others

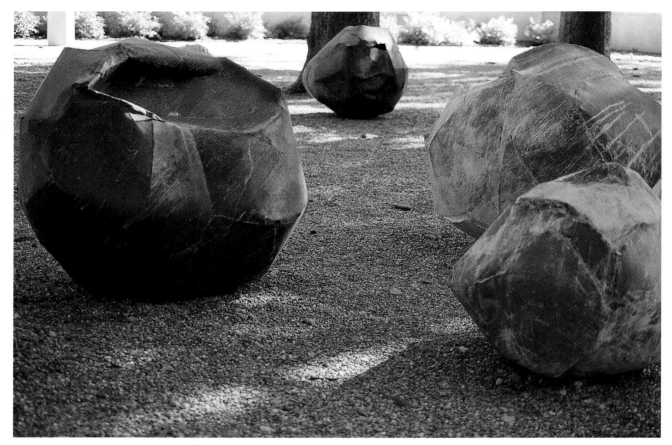

Grace Knowlton
Group of Four
copper with patina
diameter: 4' (1.2 m) each
Katonah Museum, Katonah, New York
photo: Grace Knowlton

among these artists have extended Modernism's explorations of space and form through their extended investigations of the sculptural possibilities of abstraction, often in concentration of particular materials and processes, as is evident in Isaac Witkin's poured-and-assembled bronze works and Jesús Bautista Moroles's powerfully suggestive and formally elegant carved granite sculptures.

Ming Fay's sculpture is representational but not realistic. His organic forms and realistic representations of fruit are taken from our everyday experience but abstracted through scale and other aesthetic manipulations. Grace Knowlton, on the other hand, works at the edgy boundary between the organic and the geometric, between natural forms and human interventions. Bruce Beasley's nonobjective bronze works exhibit a tentative balance and a lyrical geometry that create visceral as well as formal effects. Anish Kapoor is perhaps better known for his gallery exhibitions, but his outdoor sculpture is equally powerful in its exploration of perception, culture, and form.

Some artists today operate outside all norms and expectations for sculpture and public art: Christo and Jeanne-Claude subsume architecture and landscape into a network of form, collaborative activity, and aesthetic process. Other artists condense a vast range of intellectual and emotional experience into more recognizably sculptural objects. William Tucker's objects in bronze and other mediums echo the human form in an abstract manner, while Toshiko Takaezu's ceramic forms are entirely abstract. Nevertheless, the works of both these artists embody in a human experience the very process of form making. Magdalena Abakanowicz works with forms, metaphors, and materials that are universal in human experience yet historically specific. As a result, her human and animal forms are some of the most powerful sculptural objects of our time.

What these artists and the others collected in *Contemporary Outdoor Sculpture* share is not a common formal approach, nor a common technical procedure, nor even a common physical site. They share a commitment to communication with a public beyond the gallery walls. Most of them do show in galleries, and in some cases, the work they show indoors is very different from their outdoor sculpture. Outdoor sculpture, whether in private gardens, designated sculpture parks, or everyday public places, addresses us in the open, in the shared space of our fears, beliefs, achievements, and shortcomings. Outdoor sculpture at its best *creates* public places—spaces where we can be challenged by a stranger's vision of human life, where we can engage in conversation or argument with that other person who,

along with ourselves, *is* the public. The sculptors whose work is collected here have created public monuments, private visions, intimate portraits, social critiques, urban embellishments, intellectual and aesthetic arguments, and comic statements. What brings their work together is not just that it is shown outdoors, but that the artists have not sought to remain in the shelter of narrowly conceived audiences or institutions—and that their sculpture embodies the intensities of artistic achievement.

Glenn Harper

MAGDALENA ABAKANOWICZ

Magdalena Abakanowicz's sculpture is neither completely abstract nor figurative, but a combination of the two. Characteristic of her work is the development of "cycles" or themes, for example, *Hand-Like Trees*. These powerful, towering bronzes suggest hollow, tree-shaped forms, with branches extending upward into the finger-like projections of a huge hand. They may be interpreted as honoring the perseverance of nature and man.

Abakanowicz was born in 1930 in Falenty, Poland. Her childhood on her family's country estate outside Warsaw was brutally interrupted by World War II. As an impressionable teenager, she experienced first hand the brutalities of the Nazi occupation, and in 1944 witnessed the doomed Warsaw uprising. These experiences continue to influence the themes and motifs explored by Abakanowicz in her sculpture.

Magdalena Abakanowicz has installed over ninety solo exhibitions in major museums and galleries throughout the Americas, Europe, Australia, and Japan. Her work appears in more than sixty museums and public collections including the Centre Georges Pompidou, Paris; the Museum of Modern Art and the Metropolitan Museum of Art, New York; and the Hakone Open Air Museum, Hakone National Park, Japan.

Space of Becalmed Beings [1]
bronze, 40 figures
3' x 2' x 2' 7" (90 cm x 63 cm x 80 cm) each
Hiroshima City Museum of Contemporary Art,
 Japan
Courtesy Marlborough Gallery, New York,
 © Magdalena Abakanowicz
photo: Jan Kosmowski

Katarsis [2]
bronze, 33 figures
8' 10" x 3' 4" x 1' 7" (2.7 m x 1 m x .5 m) each
Spazi d'Arte, Collection of Giuliano Gori, Italy
Courtesy Marlborough Gallery, New York,
 © Magdalena Abakanowicz
photo: Jan Kosmowski

Katarsis, view 2 [3]
Courtesy Marlborough Gallery, New York,
 © Magdalena Abakanowicz
photo: Jan Kosmowski

Space of Nine Figures [4]
bronze
8' 6" x 4' 11" x 2' (2.6 m x 1.4 m x .6 m) each
Wilhelm-Lehbruck Museum, Duisburg,
 Germany
Courtesy Marlborough Gallery, New York,
 © Magdalena Abakanowicz
photo: Jan Kosmowski

Space of Nine Figures, view 2 [5]
Courtesy Marlborough Gallery, New York,
 © Magdalena Abakanowicz
photo: Jan Kosmowski

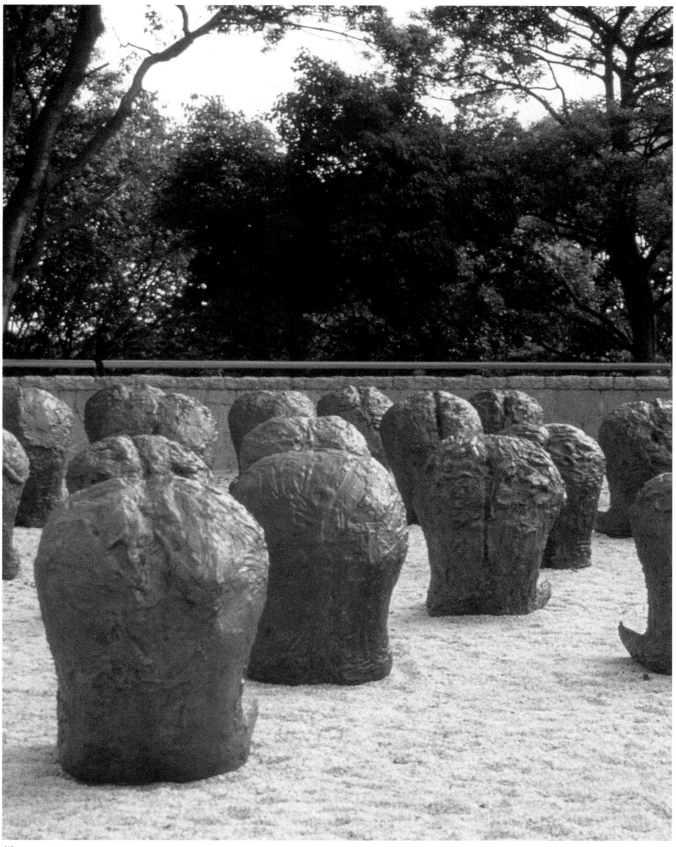

[1]

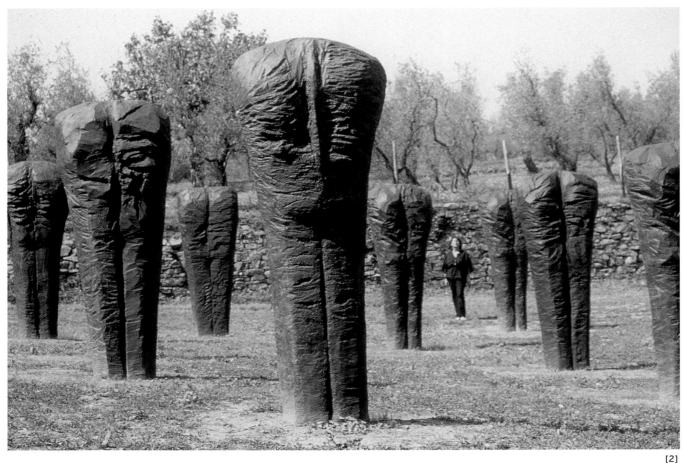

[2]

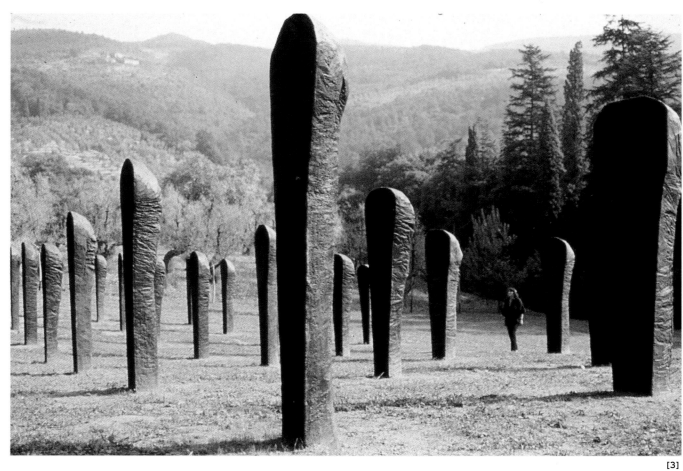

[3]

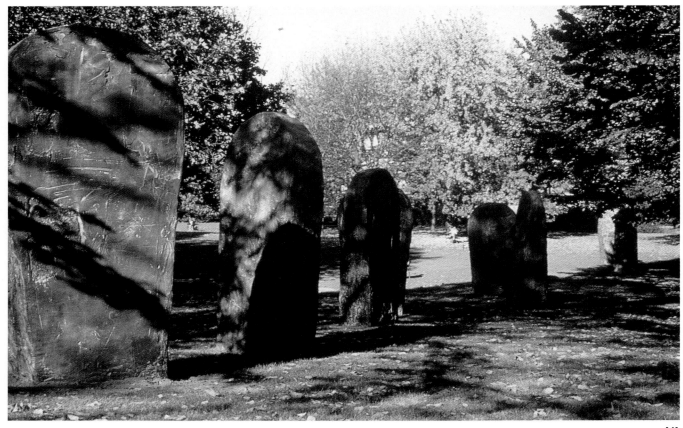

[4]

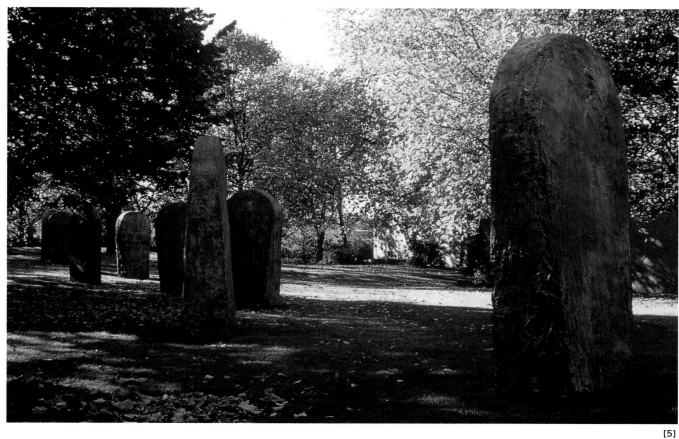

[5]

BRUCE BEASLEY

Bruce Beasley, a noteworthy West Coast sculptor, was born in Los Angeles in 1939 and currently works in Oakland. Always interested in experimenting with new technology, in the late 1960s Beasley pioneered a new sculptural technique using an autoclave to create large, cast acrylic, transparent sculpture. *Apolymon* was the first of these clear works, whose internal and external forms are dramatized by the light and color that permeates the piece. After successfully completing a series of these sculptures, he turned to new materials more suitable to producing the crystalline structured, hexagonal forms that characterize his subsequent work. Stainless steel, Cor-ten steel, and, most recently, bronze are utilized in conjunction with a sophisticated computer program to develop models for his sculpture, which are then cast or fabricated.

Inspired by forms found in nature and aided by science and technology, Beasley's dynamic sculpture has been represented in nearly forty solo and many more group exhibitions around the world. Selected collections where his work may be found are: Stadtische Kunsthalle Mannheim, Mannheim, Germany; Musee d'Art Moderne, Paris, France; Museum of Modern Art, New York, New York; and Xantus Janos Museum, Gyor, Hungary.

Tragamon [1]
cast acrylic
height: 7' 6" (2.3 m)
Entry pond, the Oakland Museum, California

Guardian [2]
bronze
17' x 11' x 9' (5.2 m x 3.4 m x 2.7 m)
Federal Loan Home Bank, San Francisco,
 California

Ceremony II [3]
cast bronze, 1 of 6
9' x 3' x 22" (2.7 m x .9 m x .5 m)
Kurpark, Bad Homberg, Germany

Apolymon [4]
cast acrylic
9' x 15' x 6' (2.7 m x 4.6 m x 1.8 m)
State of California office buildings, Sacramento,
 California

Dorion [5]
stainless steel
20' x 30' x 10' (6.1 m x 9.1 m x 3 m)
Grounds For Sculpture, Hamilton, New Jersey
photo: Ricardo Barros

[1]

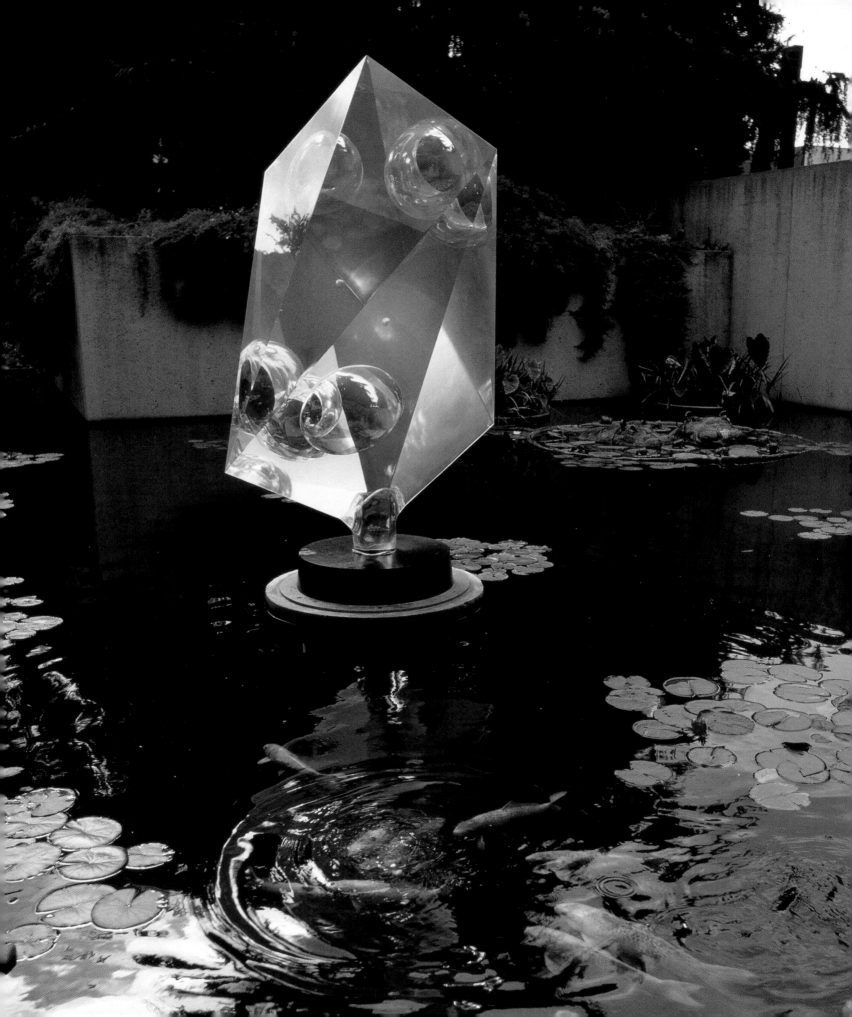

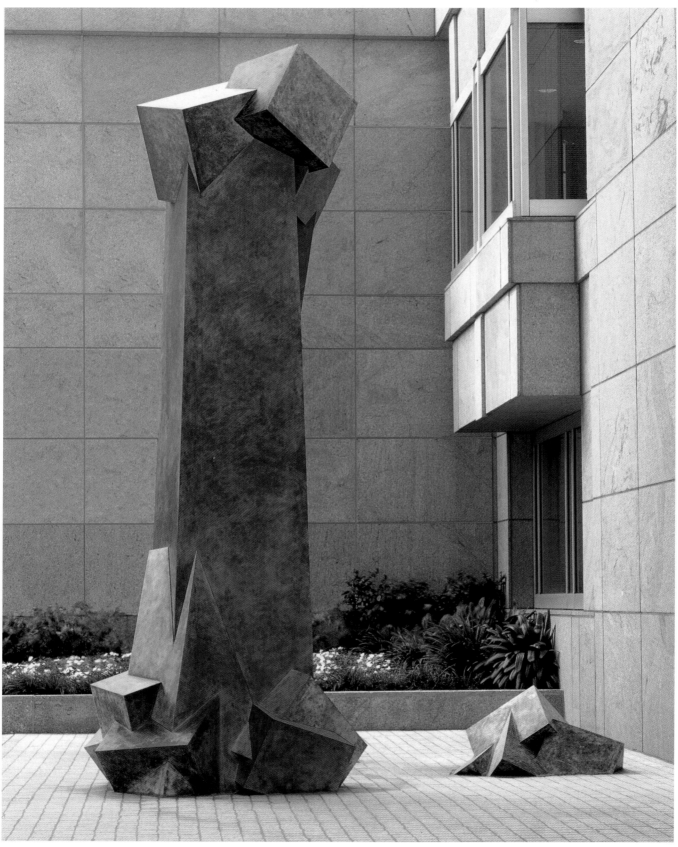

[2]

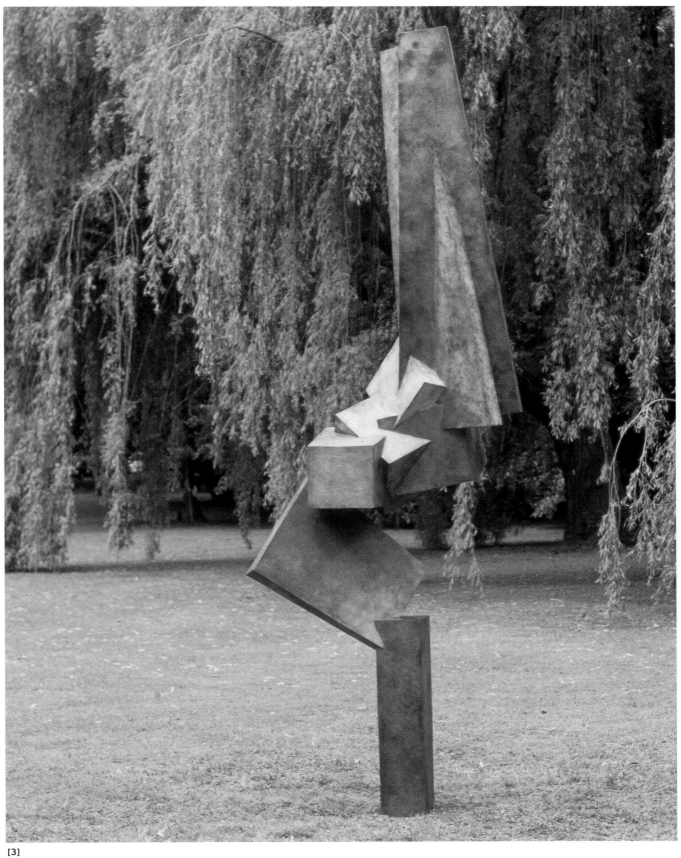

[3]

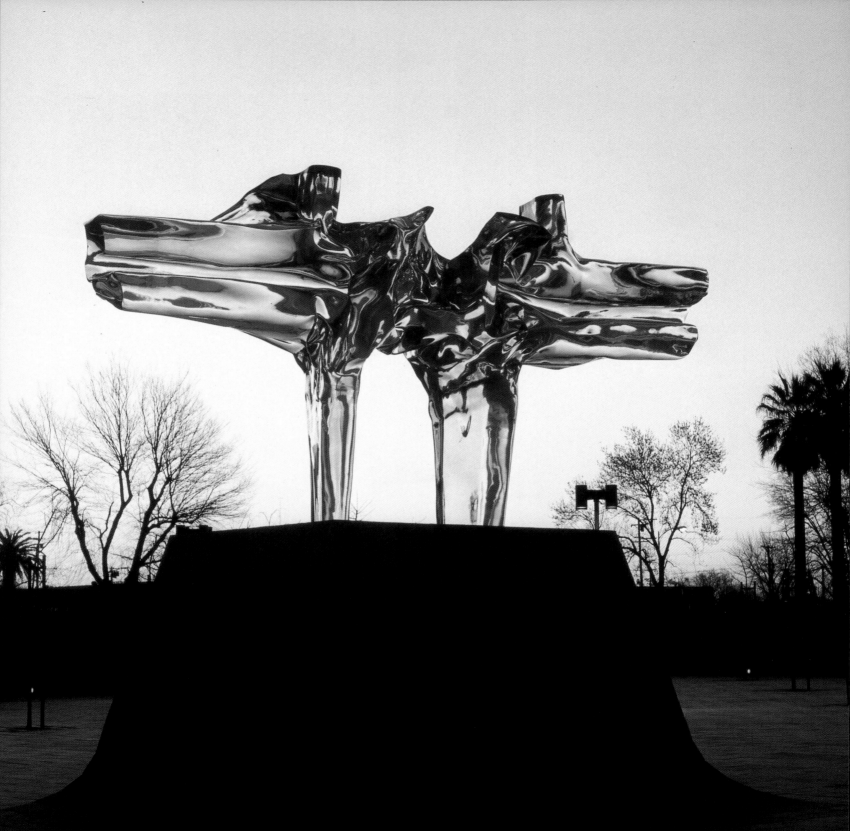

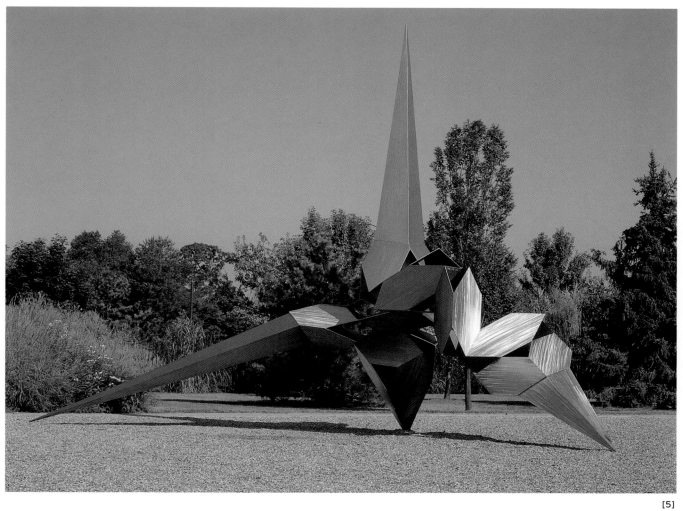

[5]

JONATHAN BOROFSKY

Born in Boston, Massachusetts in 1942, Jonathan Borofsky has exhibited his work in over eighty solo exhibitions since 1973. With still more group exhibitions to his credit, Borofsky is represented in public collections worldwide, including the Kunstmuseum in Basel, Switzerland; the Walker Art Center in Minneapolis, Minnesota; and the Hakone Open Air Museum, Hakone, Japan.

Initially a painter, Borofsky has worked in a variety of mediums, including drawing, video, light, sound, and installations. In the realm of outdoor sculpture, he is known for his monumental figurative cutouts in steel or aluminum plate, which he began to make in the 1970s. With some works towering as high as 70 feet, these immense silhouettes are arresting when sited in proximity to architecture or freestanding in the landscape. Sometimes the artist places his figures in the act of striding up or across cantilevered tubes or horizontal bars, or even across the roofline of a building. Some are motorized, as in *Hammering Man*, and others use sound as a component, as in *Singing Man*.

Man with Briefcase [1]
Cor-ten steel
30' x 13' 6" x 2" (9.1 m x 4.1 m x 5 cm)
General Mills, Minneapolis, Minnesota
Courtesy Paula Cooper Gallery, New York

Molecule Men 2+2 [2]
clear-coated aluminum plate
32' x 25' 10" x 25' 10" (9.8 m x 7.8 m x 7.8 m)
General Services Administration Commission,
 U.S. Federal Building, Los Angeles,
 California
Courtesy Paula Cooper Gallery, New York

Singing Man [3]
*aluminum, electric motor, speaker,
 compact-disc recording of artist's voice
 chanting a psalm*
18' x 5' 3" x 3' 4" (5.5 m x 1.6 m x 1 m)
Project for 1994 Chicago Art Fair
Courtesy Paula Cooper Gallery, New York

Walking Man [4]
fiberglass, hand-shaped over steel
56' x 57' 6" x 19' 8" (17.1 m x 17.5 m x 6 m)
Munich, Munich Re, Germany
Courtesy Paula Cooper Gallery, New York

Hammering Man [5]
*painted Cor-ten steel, motorized arm,
 3/8" aluminum plate*
44' x 19' 6" (13.4 m x 5.9 m)
Swiss Bank, Basel, Switzerland
Courtesy Paula Cooper Gallery, New York

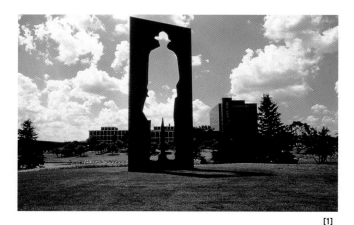

[1]

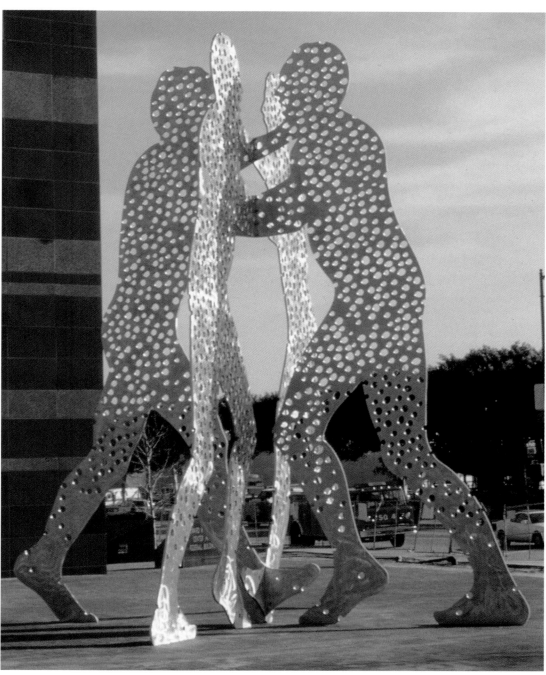

[2]

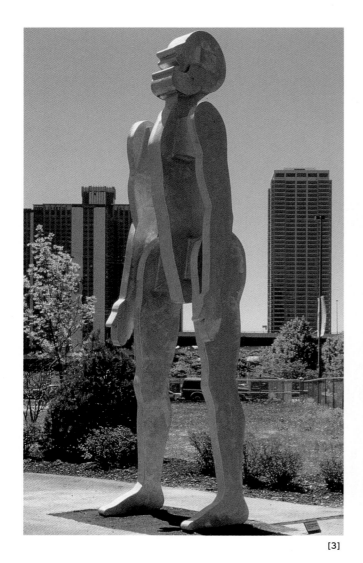

[3]

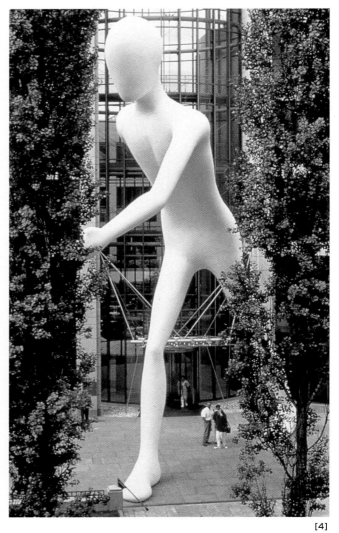

[4]

[5]

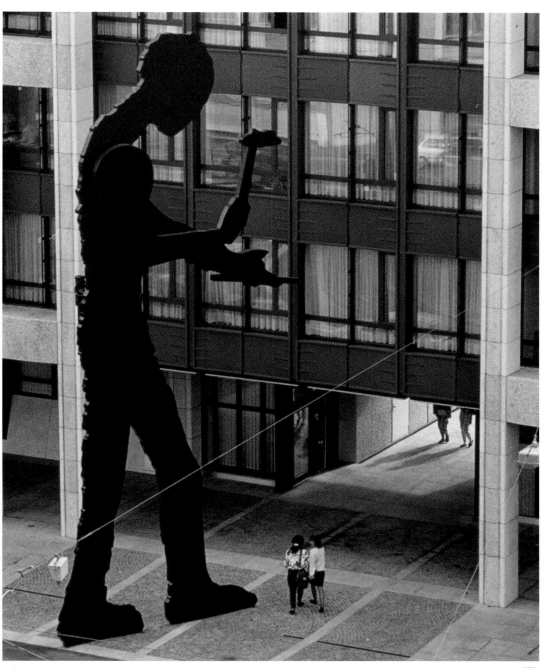

[5]

FERNANDO BOTERO

Initially a painter, Fernando Botero began making sculpture in 1973 after moving his studio from New York to Paris. Extending his distinctive painting style to three-dimensional work, Botero creates massive, voluptuous human and animal sculptures. The figures are characteristically rotund yet extremely delicate and well balanced. The artist uses volume to convey a feeling of sensuality, as well as satire. In 1993, fourteen of these monumental bronzes were exhibited along Park Avenue in New York City. His sculpture has also been placed in temporary exhibitions along avenues and boulevards in major cities around the world: the Champs-Elysees, Paris; Constitution Avenue in Washington, D.C.; Michigan Avenue, Chicago; and Madrid's Paseo de Recoletos.

Since 1951 Fernando Botero has participated in well over one hundred solo exhibitions of his sculpture and painting. Born in Medellín, Columbia in 1932, Botero's sculpture is represented worldwide in many prestigious public collections: the Hirshhorn Museum and Sculpture Garden, the Smithsonian Institution, Washington, D.C.; Museo de Arte Moderno, Bogota, Columbia; the Setagaya Art Museum, Tokyo, Japan; and the Israel Museum, Jerusalem.

Man (Dressed) [1]
bronze, 1 of 3
9' 9" x 3' 2" x 2' 6" (3 m x 1 m x .8 m)
Park Avenue, New York, New York
© Fernando Botero, courtesy Marlborough
 Gallery, New York

Male Torso [2]
bronze
12' 9" x 8' 2" x 5' 5" (3.9 m x 2.5 m x 1.7 m)
Park Avenue, New York, New York
© Fernando Botero, courtesy Marlborough
 Gallery, New York

Woman [3]
bronze, 1 of 3
10' 3" x 4' 1" x 2' 6" (3.1 m x 1.2 m x .8 m)
Park Avenue, New York, New York
© Fernando Botero, courtesy Marlborough
 Gallery, New York

Man on a Horse [4]
bronze, 1 of 3
8' x 4' 6" x 5' 3" (2.4 m x 1.4 m x 1.6 m)
Park Avenue, New York, New York
© Fernando Botero, courtesy Marlborough
 Gallery, New York

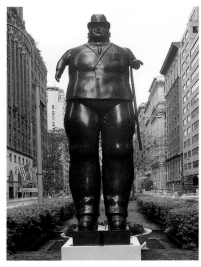

[1]

[2]

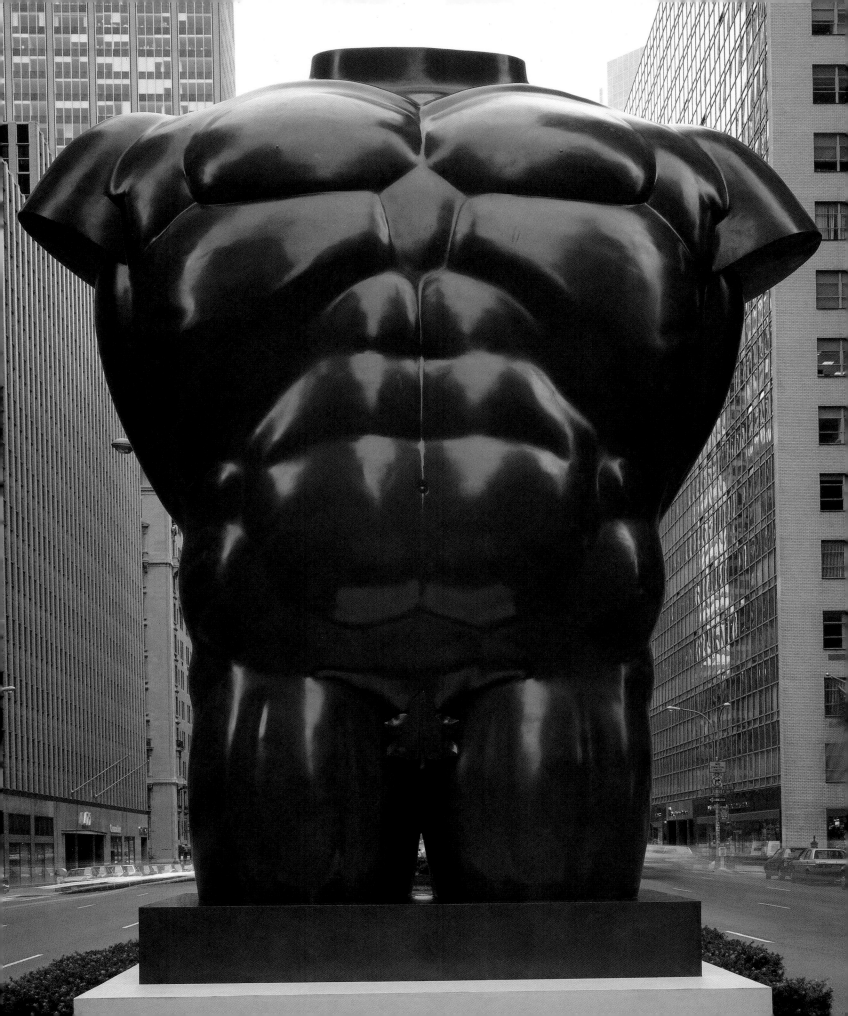

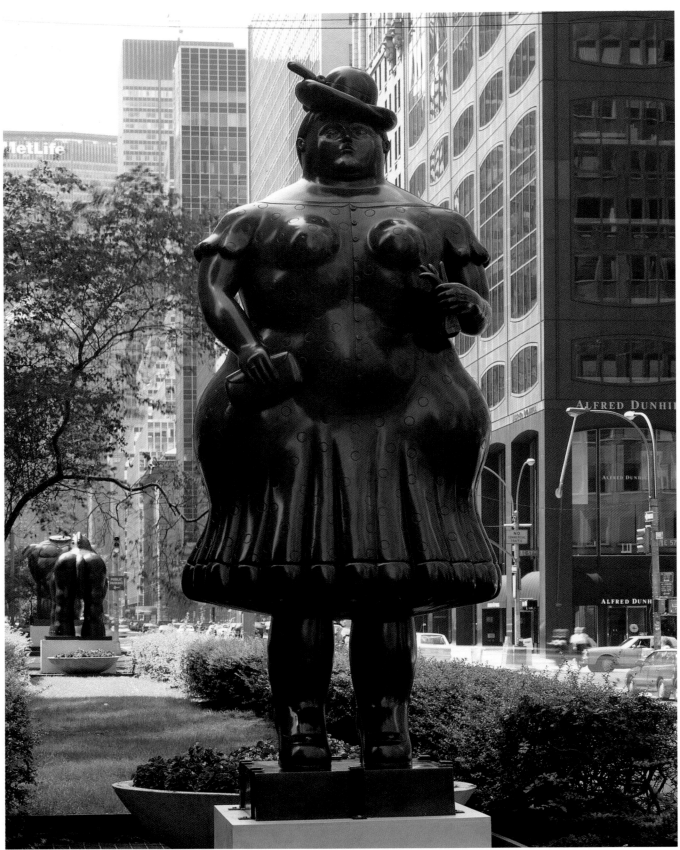

[3]

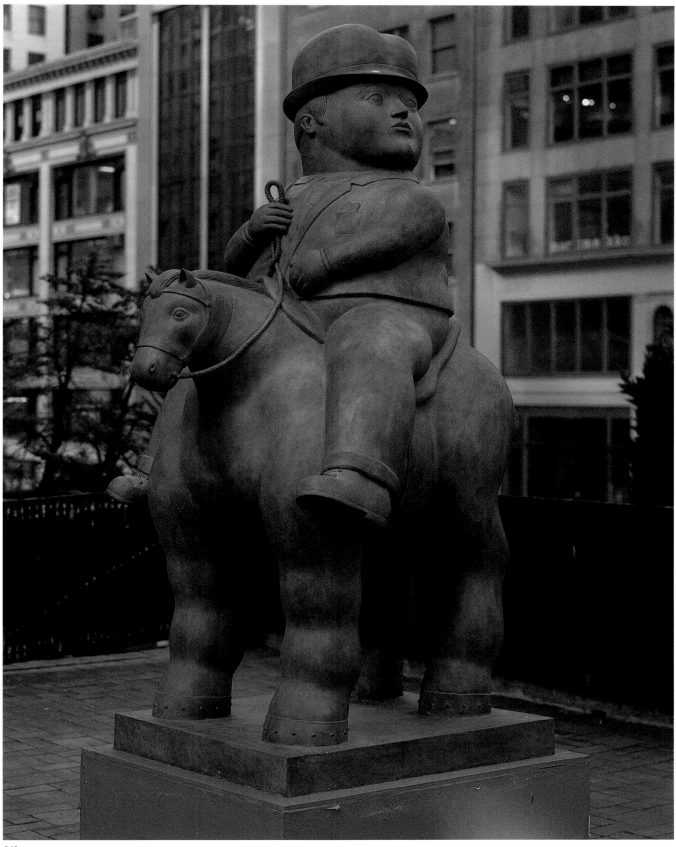

[4]

DEBORAH BUTTERFIELD

"...I am more and more interested in how each horse thinks, and hope that my work begins to feel more like horses than even to look like them."

Deborah Butterfield

Deborah Butterfield has used the theme of the horse as her vehicle for creative expression for the past twenty years. Her first horses were made of plaster and possessed a calm and gentle presence. Later, they were made of mud and sticks and suggested that they were "left clotted together after a river flooded and subsided." More recently, found materials such as scrap wood and steel have been incorporated, with some sculptures being transferred into bronze. Butterfield skillfully captures the essence of the horse, with each one possessing its own individuality. She also exposes the interior space, working with figure and ground, "merging external world with the subject."

Born in San Diego, California in 1947, Butterfield's sculpture has been shown in over fifty one-person exhibitions. Public collections that include her work are: the Art Institute of Chicago, Illinois; the Whitney Museum of American Art, New York, New York; the San Francisco Museum of Modern Art, San Francisco, California; and the Israel Museum, Jerusalem.

Two Dot, (foreground)
Horse Butte, Cottonwood Creek, Holualoa, Palani, (background, left to right) [1]
bronze with patina
7' 6" x 10' 2" x 3' 6" (2.3 m x 3.1 m x 1.1 m)
Grant Park, Chicago, Illinois
photo: Zolla/Lieberman Gallery Inc.

Woodrow [2]
bronze
height: 7' (2.1 m)
Walker Art Center, Minneapolis, Minnesota
photo: Edward Thorp Gallery, New York

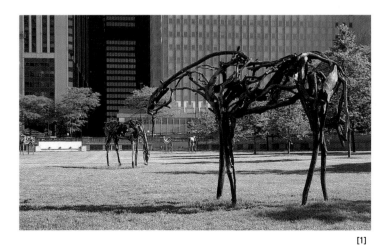

[1]

[2]

MURIEL CASTANIS

Muriel Castanis has been exhibiting her sculpture since the late 1960s. Using a process of impregnating cloth with epoxy resins that she developed over twenty years ago, Castanis creates unique, ghost-like personages of draped material. The forms convey a sense of classical grace and antiquity, and seem quite voluminous despite their thinness and hollow center. The artist states, "Consider how we accept cloth only in relation to firmer structures, be the object a chair, table, grouping of boxes or even the human form. Freezing the cloth with resins enables me to remove these distractions, giving the cloth a separate reality. In this state, the fabric not only describes the subject but transforms it with the unique personality its own character contributes." For outdoor placements Castanis' work has been cast into bronze and sited on top of buildings, public grounds, libraries, atriums, and courthouses.

The artist was born in New York City in 1926, has had more than twenty solo exhibitions of her work throughout the United States, and has participated in over eighty group exhibitions both here and abroad. *Frontiers in Fiber: The Americans,* a major group exhibition originating at the North Dakota Museum of Art in Grand Rapids, traveled for three years to nine other international venues. Her sculpture can be found in the collections of: the Norton Gallery of Art, West Palm Beach, Florida; Virlane Foundation, New Orleans, Louisiana; and the New School for Social Research, New York, New York.

Philip Johnson Commission with John Burgee Architects [1]
reinforced fiberglass
12' x 8' x 6' (3.7 m x 2.4 m x 1.8 m) each
3 of 12 sculptures positioned atop 580
California St., San Francisco, California
photo: George Castanis

Ideals [2]
bronze
6' 6" x 3' x 2' (2 m x .9 m x .6 m)
Portland State Office Building, Portland,
 Oregon
photo: George Castanis

Spirit of Freedom [3]
bronze
6' 4" x 3' x 3' (1.9 m x .9 m x .9 m)
Montgomery County Courthouse, Rockville,
 Maryland
photo: George Castanis

Spirit of Freedom, view 2 [4]
photo: George Castanis

Reading [5]
bronze
6' 4" x 3' x 2' (1.9 m x .9 m x .6 m)
Arizona State University, Tempe, Arizona
photo: George Castanis

[1]

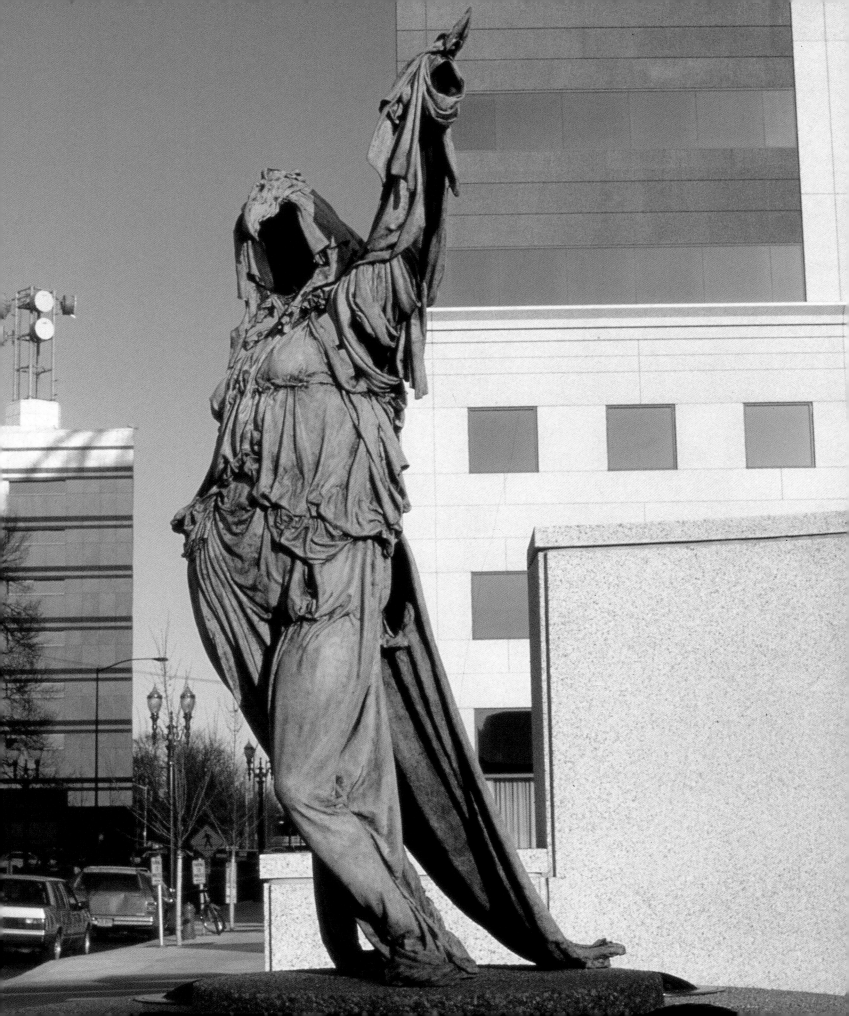

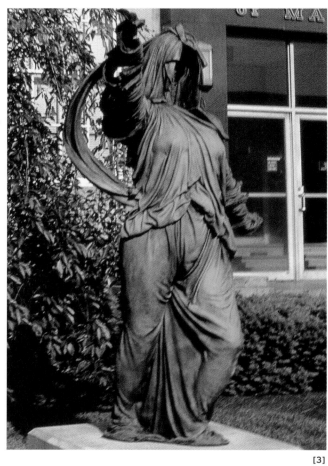

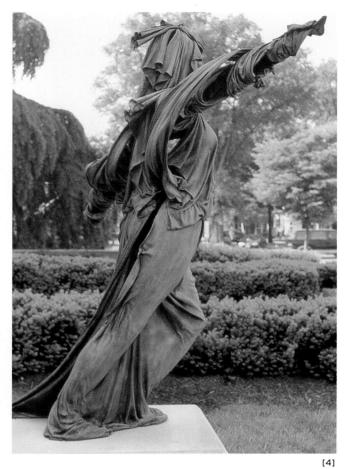

[3]

[4]

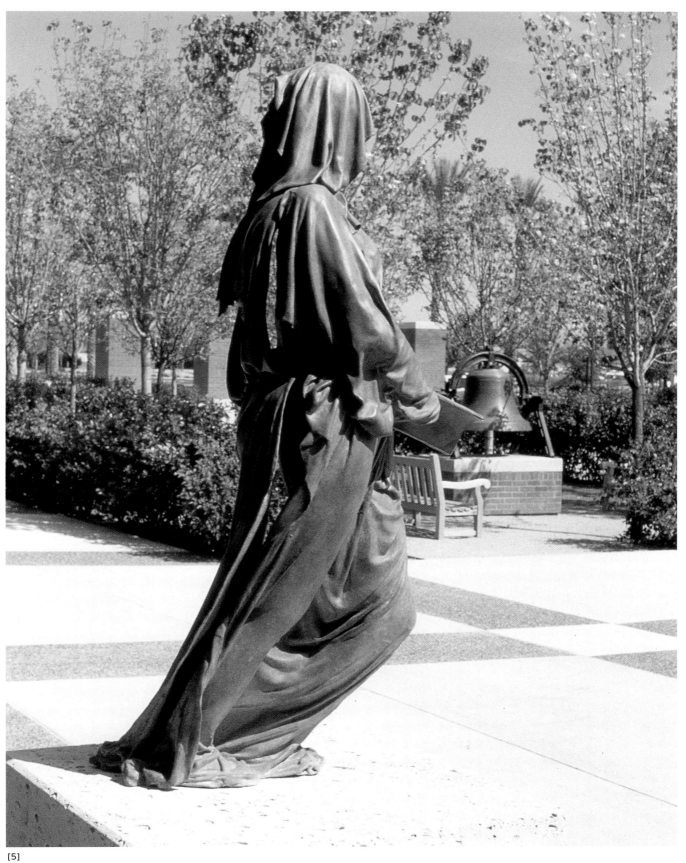

[5]

CHRISTO AND JEANNE-CLAUDE

Christo and Jeanne-Claude were born on the same day in 1935, Christo in Bulgaria and Jeanne-Claude in Morocco. They met in Paris in 1958, and moved to New York City in 1964. Since their first collaboration in 1961, they have completed dozens of projects all over the world, primarily dealing with fabric in the creation of their works of art.

Throughout the history of art, the use of fabric has been a fascination for artists. From the most ancient times fabric—forming folds, pleats and draperies—has been a significant part of painting and sculpture. Christo and Jeanne-Claude's use of fabric follows this classical tradition. The artists state, "Fabric, like clothing or skin, is fragile, it translates the unique quality of impermanence."

The artwork of Christo and Jeanne-Claude is entirely financed by the artists, through the sale of preparatory studies, drawings, collages, and scale models as well as early works and original lithographs. The artists do not accept sponsorship of any kind. They have completed projects for many varied geographic locations and architectural sites worldwide. One highlight is *The Umbrellas, Japan-U.S.A.*, 1984–1991, 1,340 blue umbrellas in Ibaraki, Japan and 1,760 yellow umbrellas in California, with each umbrella looming 19' 8'' in height and 28' 6'' in diameter.

The artists are currently working on three major projects: *The Mastaba of Abu Dhabi, Project for the United Arab Emirates*, begun in 1979; *The Gates, Project for Central Park New York City*, also begun in 1979; and *Over the River, Project for the Arkansas River, Colorado*, begun in 1992.

Running Fence, 1972-1976 [1]
Sonoma and Marin Counties, California
Copyright: Christo 1976
photo: Jeanne-Claude
Running Fence, 18 feet high and 24.5 miles long, extended east-west on the private properties of 59 ranchers, following the rolling hills and dropping down to the Pacific Ocean at Bodega Bay. It was made of a heavy woven white nylon fabric, hung from a steel cable strung between 2,050 steel poles, braced with guy wires and earth anchors. Designed to be viewed by following 40 miles of public roads, after fourteen days *Running Fence* was removed and the materials given to the ranchers.

Wrapped Reichstag, 1971-1995 [2]
Berlin
Copyright: Christo 1995
photo: Wolfgang Volz
After a struggle of twenty-four years, the wrapping of the Reichstag was completed on June 24, 1995 by a workforce of ninety professional climbers and 120 installation workers. Over one million square feet of thick, woven polypropylene fabric with an aluminum surface and 51,181 feet of blue polypropylene rope were used. The richness of the silvery fabric, shaped by the blue ropes, created a sumptuous flow of vertical folds highlighting the features and proportions of the imposing structure. The Reichstag remained wrapped for fourteen days and all materials were recycled.

[1]

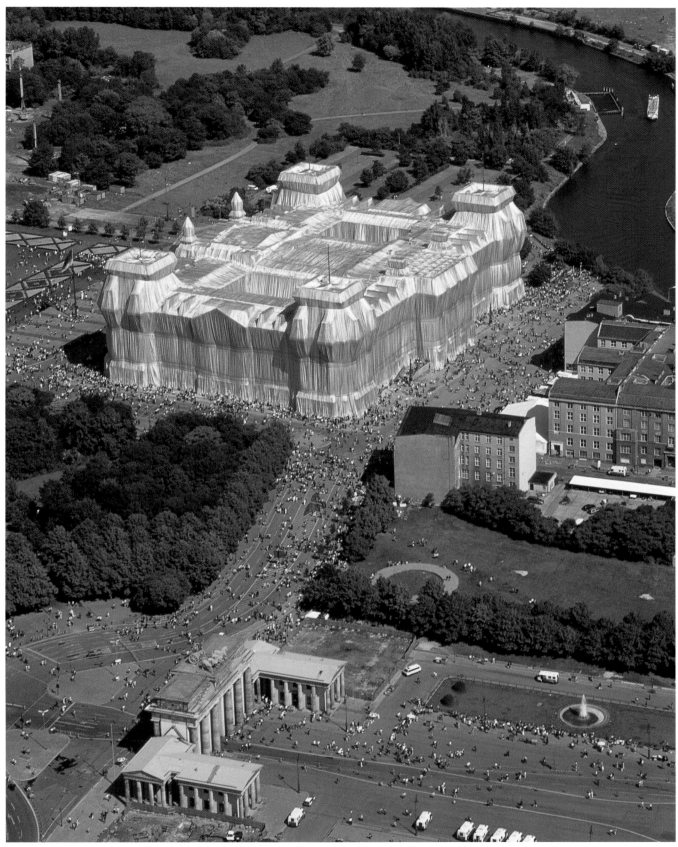

MICHELE OKA DONER

Michele Oka Doner is well known for her work in public places, most notably: *Radiant Site*, a 150-foot-long wall composed of 11,000 gold luster tiles at the Herald Square subway complex in New York; *A Walk on the Beach*, a 22,000-square-foot work on the floor of Concourse A at Miami International Airport; and *Celestial Plaza*, at Hayden Planetarium in New York.

A native of Miami Beach, Oka Doner will be represented by a retrospective exhibition of three decades of her work opening at the Bass Museum in Florida and traveling to several venues in the United States, Europe, and South America. Her work is included in public collections of the Metropolitan Museum of Art in New York, the Art Institute of Chicago, and the National Design Museum-Smithsonian Institution, New York.

Oka Doner's technique of embedding bronze artifacts in concrete and other surfaces reveals the artist's deep affinity for the marvels of the natural world and its ongoing processes. She was commissioned by the City of Santa Monica Percent for Art Program in 1986 to create a site-specific sculpture for Ocean Park Beach. She constructed a pair of 13' 6'' vertical armatures, immersed them in the lagoon, and introduced a small amount of electrical current. The minerals inherent in sea water were drawn to the armatures. To date, they have accreted inches of thickness, supporting mineral and biological growth.

Cluster, from *Celestial Plaza* [1]
Untitled, from *Celestial Plaza*
River and Fragment, from *Celestial Plaza*

Celestial Plaza, photographed at night [2]
bronze, concrete
12' x 30' (3.7 m x 9.1 m)
American Museum of Natural History, Hayden
 Planetarium, New York, New York

Ice Rings [3]
bronze
diameter: 10' (3 m)
Ingalls Mall, University of Michigan, Ann Arbor,
 Michigan

Physics Bench [4]
bronze
diameter: 7' (2.1 m)
Ingalls Mall, University of Michigan, Ann Arbor,
 Michigan

Physics Bench, detail [5]

[1]

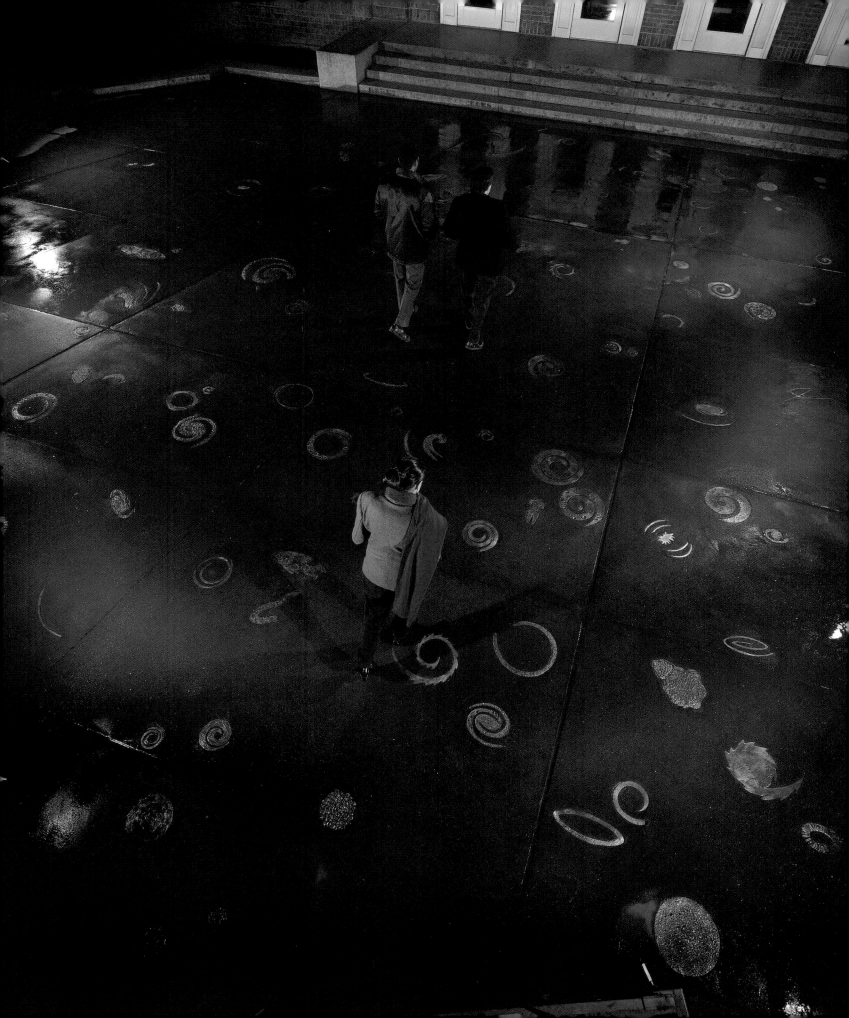

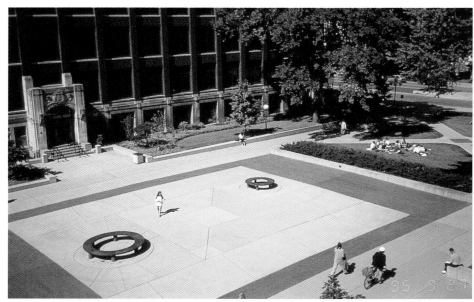

[3]

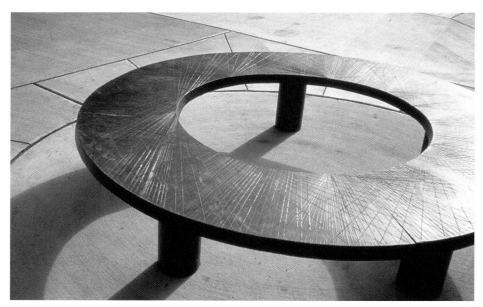

[4]

[5]

MING FAY

For the past twenty years, Ming Fay has focused his attention on organic forms in nature. He began to create what he refers to as a sculptural *celestial garden* from man-made materials. Each piece stands on its own, yet it is part of the sum total of his works governed by this mythological theme. His naturalistic objects reflect an attitude of meditation, a result of the artist's imagination and cross-cultural experiences. Based on Taoist principles, Fay's celestial garden suggests the inclusive relationship among all things in nature.

In speaking about his creative process Fay states, "When the pieces mix and get arranged in specific sites they become a mystery, which provides a pulse that resonates with a personal, subconscious memory. It is a mining of forms from the recognizable, natural world, and yet these forms are inexplicably linked to other-worldly sources. Shapes and images slip in and out of organic, biological paths and become three-dimensional realities."

Born in Shanghai, China, in 1943 and raised in Hong Kong, Ming Fay has lived in the United States for 36 years. The artist's iconography of oversized fruits, vegetables, seeds, pods and roots are drawn from nature and under his inspiration become both fantastic and mysterious. Fay has participated in nearly twenty solo exhibitions and twice as many group shows since 1988.

Qián Vien, detail [1]
epoxy, wire, luxor
9" x 11" (23 cm x 28 cm) each
William Paterson University, Wayne, New Jersey
Qián is the Chinese word for money.
Courtesy of Artist
photo: Ming Fay

Bell Sprout [2]
epoxy, steel, polymer cement
height: 14' (4.3 m)
Petrosino Park, Soho, New York
Courtesy of Artist
photo: Ming Fay

Leaf Gate [3]
painted steel
14' x 6' x 2" (4.3 m x 1.8 m x 5 cm)
P.S. 7, Elmhurst, New York
Courtesy of Artist
photo: Ming Fay

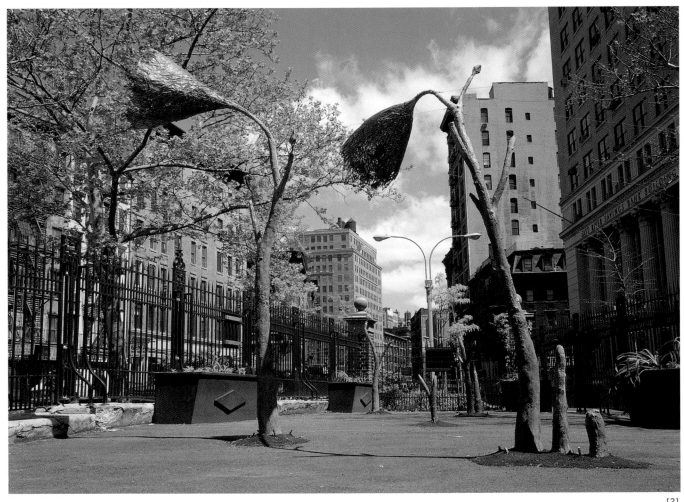

[2]

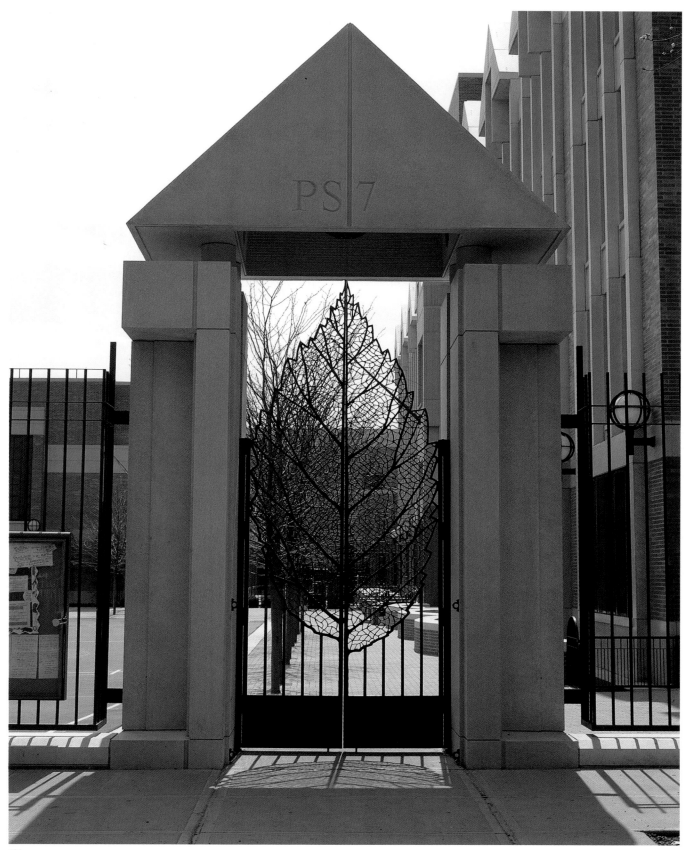

[3]

AUDREY FLACK

Audrey Flack achieved international recognition in the 1960s and 1970s as a leading figure among the Photo Realist painters. She began to create monumental sculptures of female figures inspired by mythological beings and goddesses in the early 1980s. These heroic, idealized works recreate Egyptian and Greco-Roman deities in a contemporary context. The most notable of her many large-scale public commissions is a monument to Queen Catherine of Braganza, for whom the Borough of Queens, New York was named. When completed, the 35 feet tall bronze sculpture is scheduled to be installed in Hunters Point, Queens, opposite the United Nations Building.

Born in 1931 in New York, Audrey Flack is represented in numerous public collections across the United States and in Australia. Since 1948 she has participated in hundreds of solo and group exhibitions of her painting and sculpture.

Model for Hunters Point, Queens [1]

Civitas: Four Visions, detail [2]
patinated and gilded bronze
height: 20' (6.1 m) for each figure, with base
Gateway to the city of Rock Hill, South Carolina
Courtesy of Artist

Quewe Pehelle [3]
bronze
height: 12' (3.7 m) with base
Lebanon Valley College, Pennsylvania
Courtesy of Artist

Quewe Pehelle, detail [4]
Courtesy of Artist

second maquette for Queen Catherine of Braganza [5]
patinated and gilded bronze
height: 4' 6" (1.4 m)
Courtesy of Artist

Islandia: Goddess of the Healing Waters, detail [6]
patinated and gilded bronze
height: 9' (2.7 m) with base
New York City Technical College,
 Brooklyn, New York
Courtesy of Artist

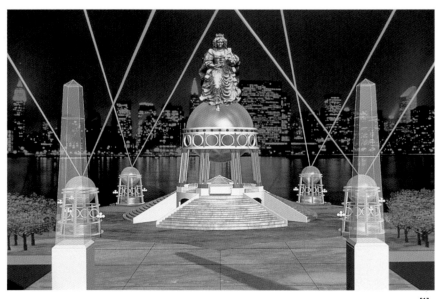

[1]

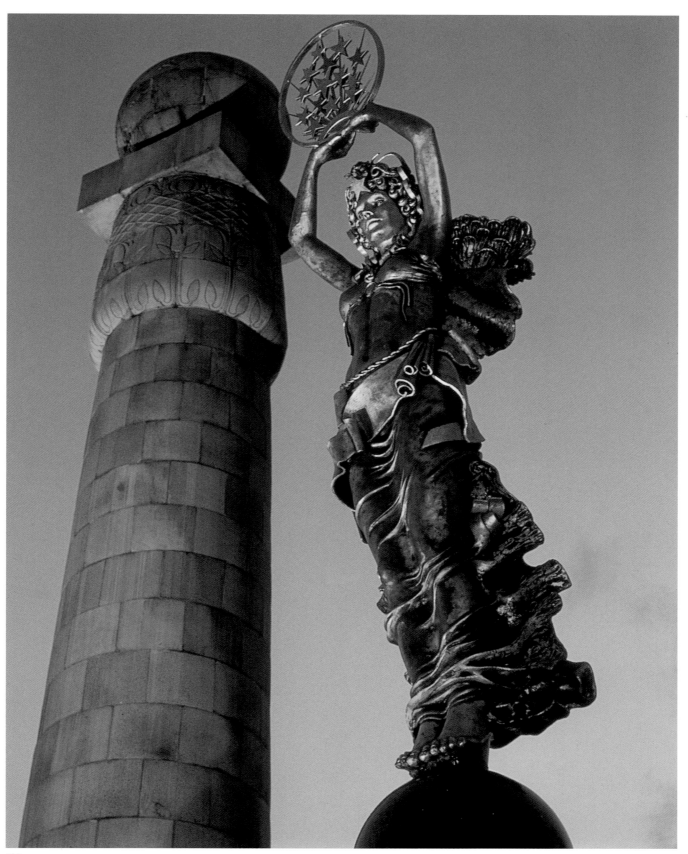

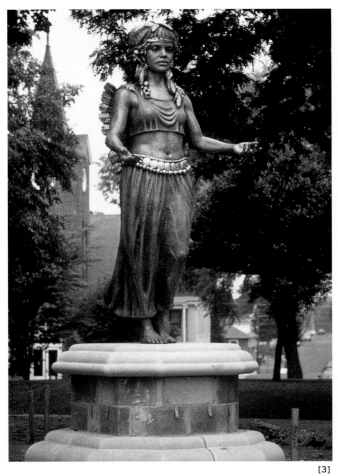

[3]

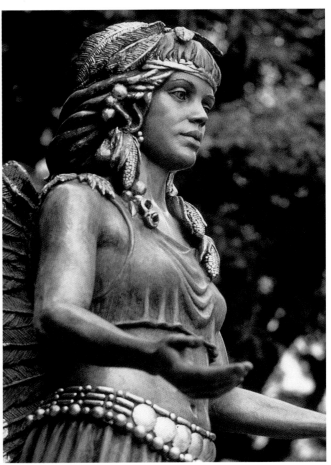

[4]

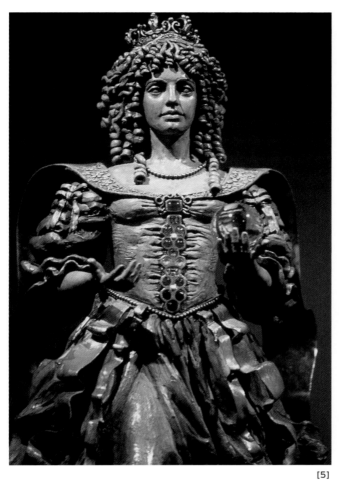

[5]

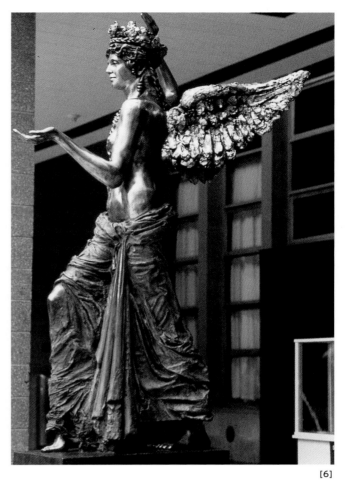

[6]

MARY FRANK

Born in London, England in 1933, Mary Frank has been exhibiting her drawing, painting, and sculpture in solo exhibitions since the late 1950s. A recipient of numerous awards and grants, her work can be found in public collections such as the Storm King Art Center, Mountainville, New York; the DeCordova Museum, Lincoln, Massachusetts; and the Museum of Modern Art, New York, New York.

Frank's work in clay begins as flat slabs, which she drapes, folds, punctures, and incises, creating sensuous forms based upon the human body. They are often placed in the landscape, which adds to the fundamental feeling in her sculpture of growth and humanity's interrelatedness with nature. The shapes and edges of the clay figures transform into leaf and plant-like forms. Frank's figures exhibit delicate gestures and evoke an optimistic spirit, conveying an expression of spontaneity and anticipation.

Head with Shadow [1]
clay
photo: Jerry Thompson

Three Dancers [2]
bronze
1' 1" x 2' 1" x 3' 3" (.3 m x .6 m x 1 m)
photo: Jerry Thompson

Sundial [3]
cast bronze
3' 9" x 1' 5" x 1' (1.1 m x .5 m x .3 m)
Grounds For Sculpture, Hamilton, New Jersey
photo: Ricardo Barros

Lover [4]
clay
1' 11" x 3' 8" x 2' 1" (.6 m x 1.1 m x .6 m)
photo: Jerry Thompson

Messenger [5]
cast bronze
Grounds For Sculpture, Hamilton, New Jersey
photo: Ricardo Barros

[1]

[2]

[3]

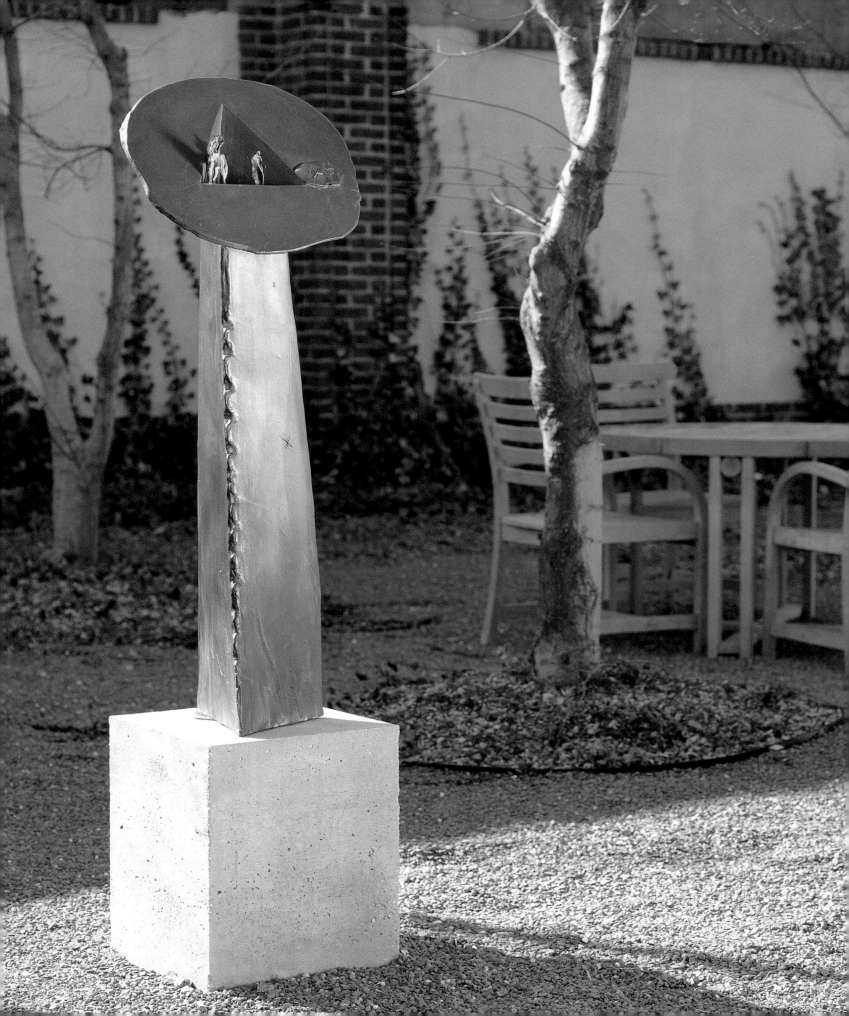

[4]

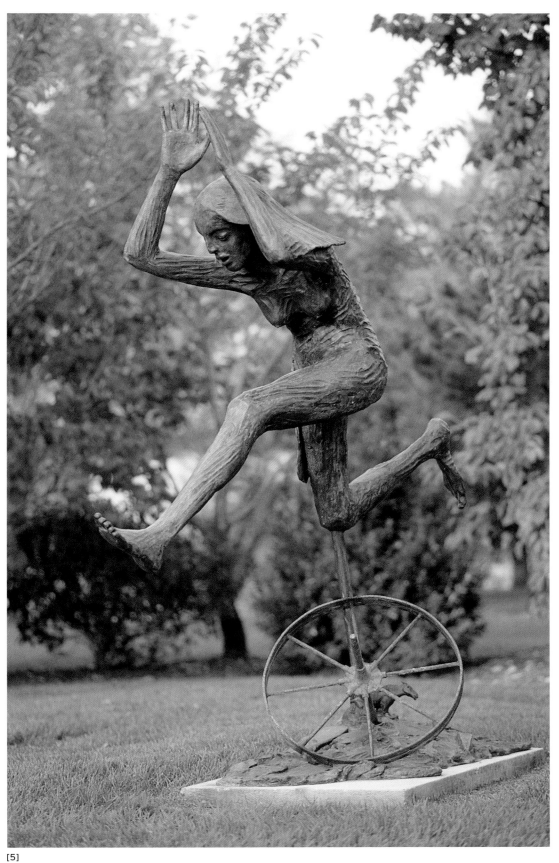

[5]

VIOLA FREY

Viola Frey, a well-established West Coast ceramic sculptor, is best known for her monumental figures of men and women, which she began making in 1976. They are often placed within the context of each other, or of the world. For example, two women, facing a globe 4 feet in diameter, appear to be thinking about its fate. The rich surfaces of these somewhat awkward, larger-than-life figures are energized with color from the glazes applied to every inch of the surface. Frey's figure groupings invite the viewer into a world of large, vibrant beings in poses suggesting both human interaction and individual contemplation. Scale is an important aspect of this artist's work. The weighty, stacked sections imply an inner force, power and dominance.

Viola Frey was born in Lodi, California in 1933. Her work has been widely shown throughout the United States, including the American Craft Museum, New York, New York; San Francisco Museum of Modern Art, San Francisco, California; and the Museum of Fine Arts, Boston, Massachusetts; and abroad at the American Center, Paris; Victoria and Albert Museum, London, England; and LaForet Museum, Tokyo. Frey's work is represented in many public collections, among them: Everson Museum of Art, Syracuse, New York; the St. Louis Art Museum, St. Louis, Missouri; and the Shigaraki Ceramic Cultural Park, Japan.

The World and the Woman [1]
ceramic
6' 8" x 11' 9" x 6' 3" (2.1 m x 3.6 m 1.9 m)
Collection of Mr. and Mrs. Irving Sands
Courtesy Nancy Hoffman Gallery, New York
photo: Sam Perry

Reclining Red Man [2]
4' x 7' 6" x 3' (1.2 m x 2.3 m x .9 m)
Orange & Yellow Hand Man
height: 9' 9" (3 m)
Big Boy
10' x 4' 11" x 2' 6" (3 m x 1.4 m x .8 m)
ceramic
Collection of Stepane Janssen
Courtesy Nancy Hoffman Gallery, New York
photo: Susan Einstein

Reclining Red Man, Orange & Yellow Hand Man, Big Boy, view 2 [3]
Courtesy Nancy Hoffman Gallery, New York
photo: Susan Einstein

Reclining Red Man, view 3 [4]
Courtesy Nancy Hoffman Gallery, New York
photo: Susan Einstein

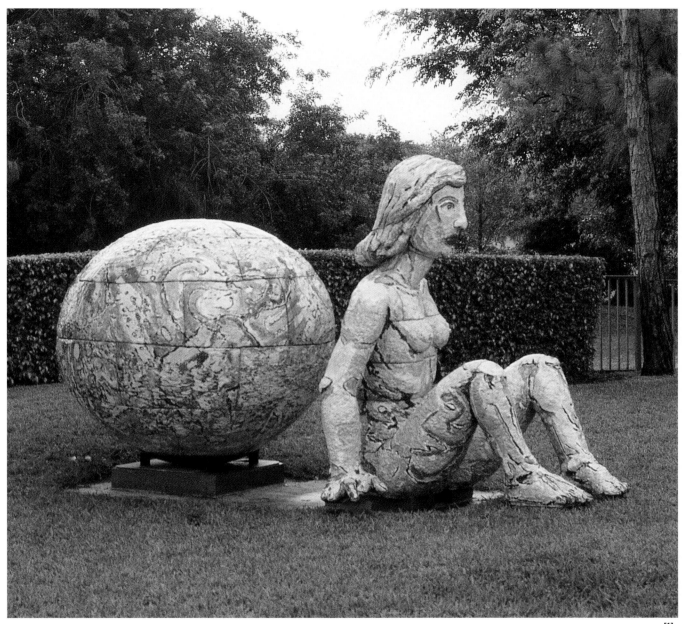

[1]

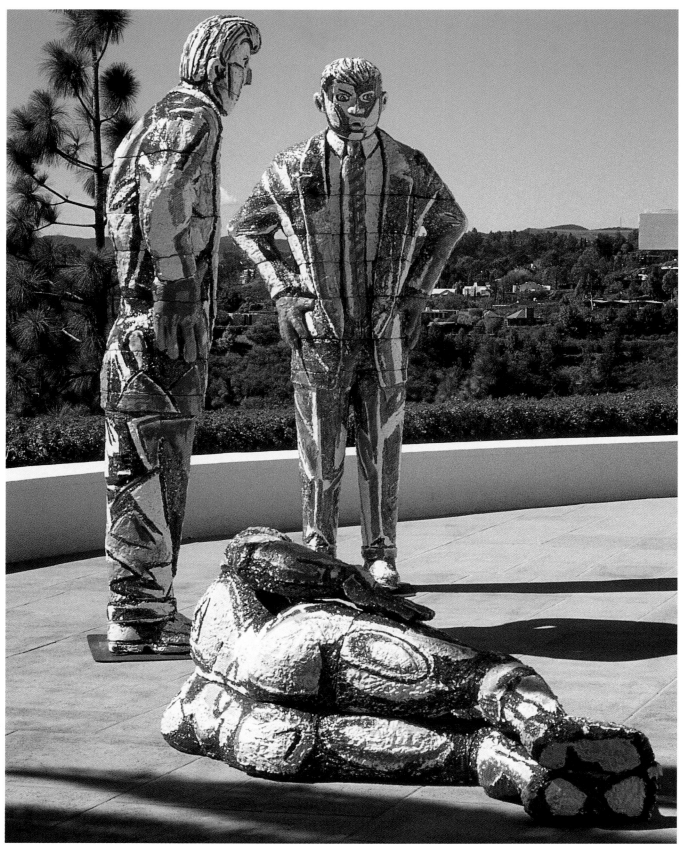

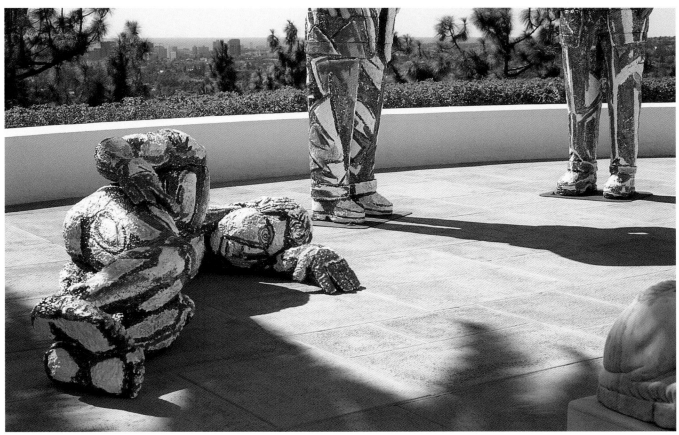

[3]

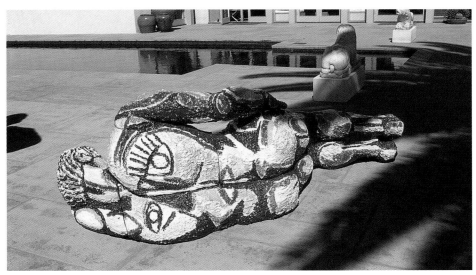

[4]

TETSUO HARADA

Tetsuo Harada, a sculptor who has worked in France for the last twenty-four years, was born in Niigata, Japan in 1949. In 1992, the Japanese Ministry of Equipment began a national program of commissioning artwork for ecologically sensitive sites throughout the country. The first project was for the Tazawako Dam, for which Harada created *Earth Weaving*, a series of works located on and next to the dam. These works, made of four types of granite, include reliefs, free-standing sculptures, and landscaping. Harada, with a team of civil engineers, endeavored to achieve harmony between the site, a nearby volcano, the natural and cultural heritage of the area, and the activity of man and technology. To Harada, *Earth Weaving* is a concept for " . . . a group of sculptures which cover the world. *Earth Weaving* creates links that traverse the planet, . . . The stitching together symbolizes a desire for a dialogue of peace, union, and love in order to reunite men, the public, and the continents."

Tetsuo Harada skillfully fits his sculptures into the urban environment, using various types of stone, bronze, and wood. He combines softly curved, smooth forms with hard-edged geometric shapes. With many solo and group exhibitions to his credit, Harada has been awarded numerous sculptural commissions. He is now working on *Earth Weaving*-related projects for Montpellier in France, and Akita, Niitsu, and Niigata, in Japan.

Monument to the 38th Parallel [1]
pink granite
13' x 18' x 16' 6" (4 m x 5.5 m x 5 m)
Kagigawa, Japan

Earth Weaving [2]
blue granite
height: 12' (3.7 m)
Bretagne, France

Earth Weaving, Tazawako Relief [3]
pink granite
52' 6" x 394' (16 m x 120.2 m)
Tazawako Dam, Akita, Japan

Earth Weaving, Tazawako Relief, view 2 [4]

**Monument to the Resistance
and the Deportation** [5]
granite
Nanterre Town Hall, France

[1]

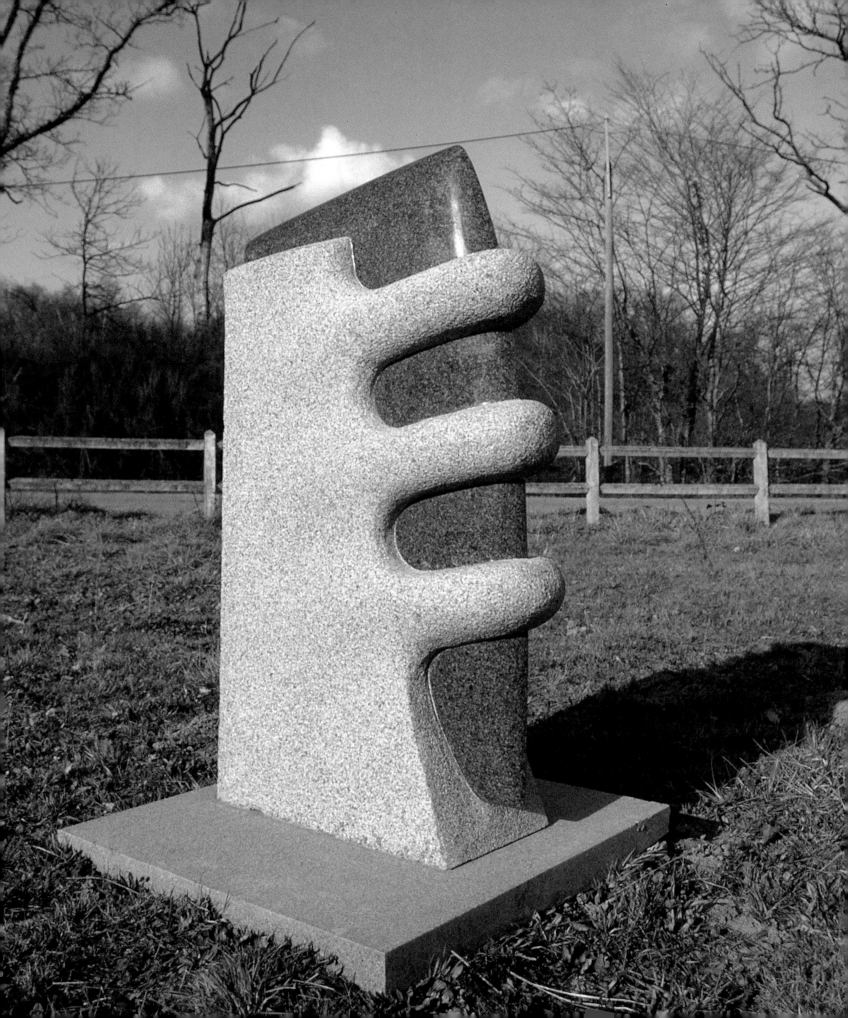

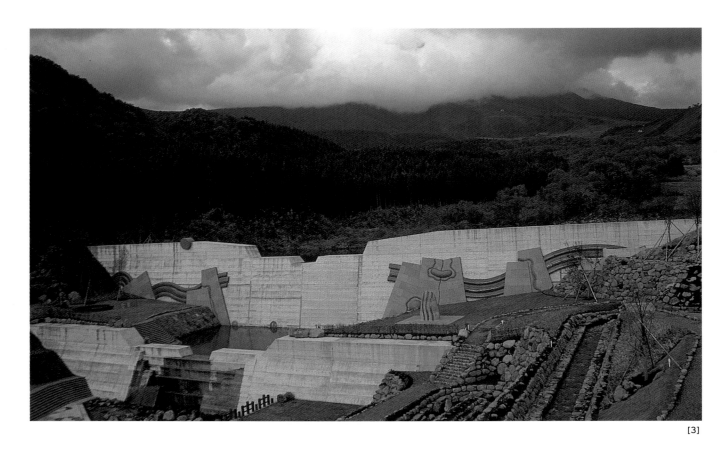

[3]

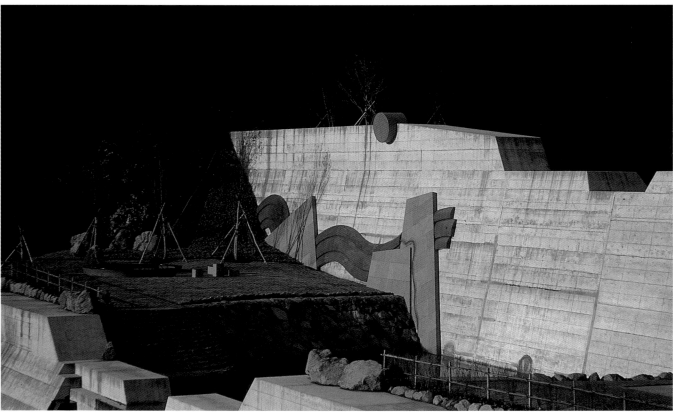

[4]

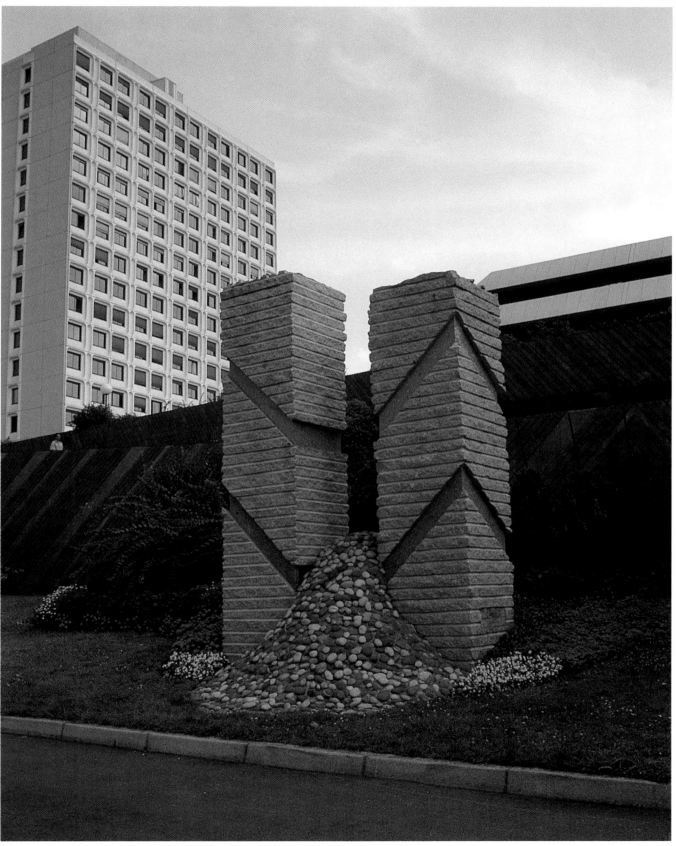

LUIS JIMÉNEZ

The sculpture of Luis Jiménez is strongly rooted in his Mexican-American heritage. His voluptuous, larger-than-life figures celebrate people in daily life. His signature style, using fiberglass as a medium, presents bold, slick, multicolored heroic figures in exaggerated action. Often incorporating landscape elements, Jiménez' sculpture portrays the life and culture of the border region of the United States and Mexico. Growing out of the Pop Art movement of the 1960s, by 1970 Jiménez began working on a series of western themes that he continues to examine. Guided by history and mythology, the public sculpture of Luis Jiménez is dynamic, communicating social, political, and spiritual issues with a visual richness and passion.

Luis Jiménez was born in El Paso, Texas in 1940. He has been exhibiting his work since 1969 in over seventy-five solo exhibitions and many more group shows. His work is represented in numerous collections across the United States and elsewhere, including the Hirshhorn Museum and Sculpture Garden and the National Museum of American Art, both in Washington, D.C.; the Centro Cultural Arte Contemporaneo, Polanco, Mexico; and the Rockefeller Foundation, New York, New York.

Plaza de los Lagartos, detail [1]
fiberglass
9' 8" x 9' 8" x 9' 8" (2.9 m x 2.9 m x 2.9 m)
San Jacinto Plaza, El Paso, Texas
photo: © Luis Jiménez

Fiesta [2]
fiberglass
height: 10' (3 m)
Collection of University of New Mexico,
 Albuquerque
photo: © Luis Jiménez

Howl [3]
bronze
5' x 3' x 3' (1.5 m x .9 m x .9 m)
photo: © Luis Jiménez

Progress I [4]
fiberglass
7' 7" x 8' 8" x 9' 9" (2.3 m x 2.7 m x 3 m)
photo: © Luis Jiménez

San Diego Fountain [5]
fiberglass, steel
92' 6" x 34' x 34' (28.2 m x 10.4 m x 10.4 m)
Horton Plaza, San Diego, California
photo: © Luis Jiménez

San Diego Fountain, detail, **Orca Panel** [6]
photo: © Luis Jiménez

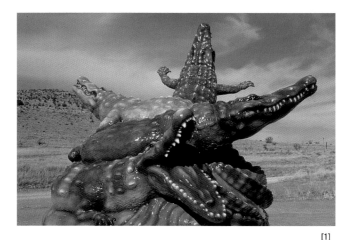

[1]

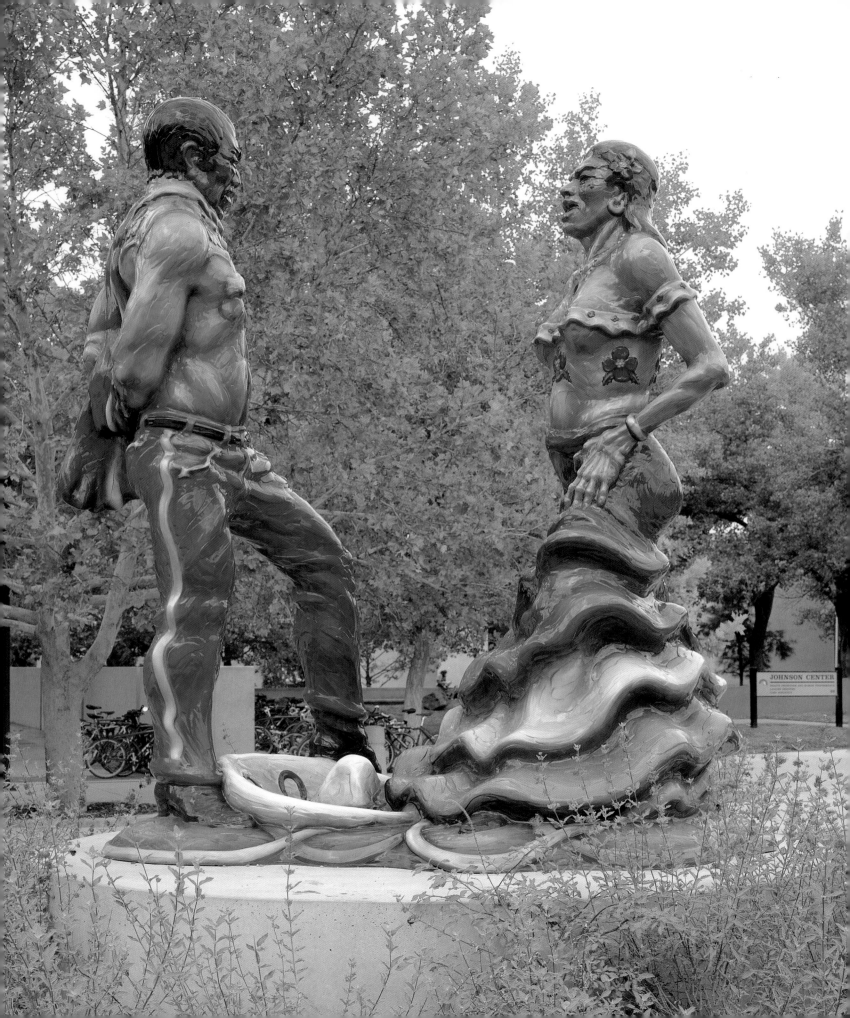

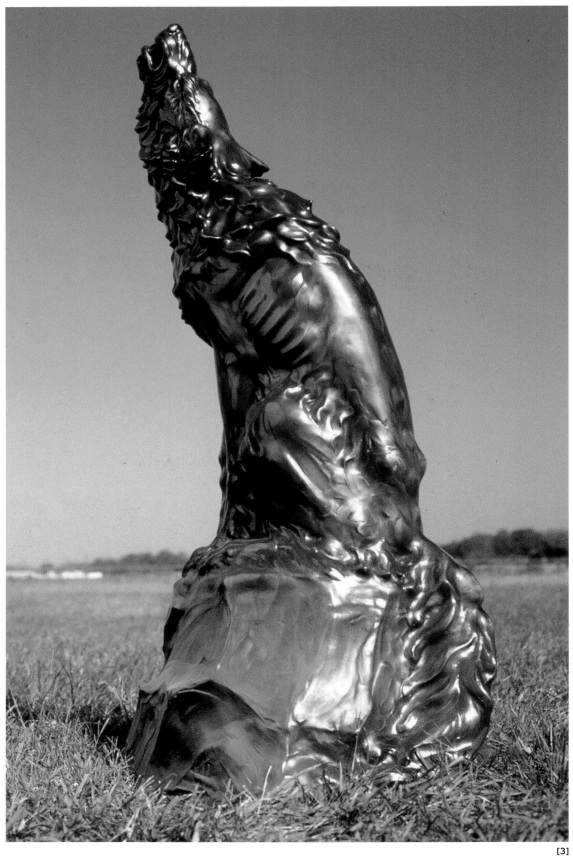

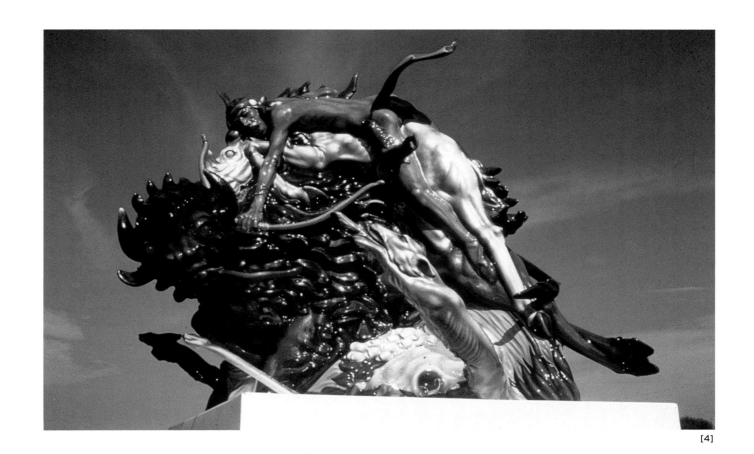

[4]

[5]

[6]

J. SEWARD JOHNSON, JR.

After many years as a painter, J. Seward Johnson, Jr. turned to creating sculpture in 1968. Since then well over two hundred of his life-size, cast-bronze figures have been featured in exhibitions and both public and private collections around the world.

What strikes the viewer on encountering one of his figures is their realism and refinement of detail. With subtle gestures and casual poses, the artist depicts familiar moments of everyday life and leisure, like sitting on a park bench or enjoying a lunch break. Johnson's sculpture is often responsible for double takes, drawing one in for a closer look at the figure, and in so doing an examination of ourselves.

Most recently, Johnson has completed a series based upon well-known Impressionist paintings by Manet, Renoir, Caillebotte, and Van Gogh. Johnson was reminded through these icons of a time when leisure was celebrated. The figures that occupy these paintings take part in activities such as dancing, picnicking, and dining at a cafe. By revisiting these images in three-dimensional form, the artist presents us with the unique opportunity to enter not only the time period but also the world of the painting, stepping into the landscape and experiencing it from multiple perspectives.

Crossing Paths [1]
life-sized cast bronze
Courtesy Sculpture Placement, Ltd.,
 Washington, D.C.

Eye of the Beholder [2]
life-sized cast bronze
Grounds For Sculpture, Hamilton, New Jersey
Courtesy Sculpture Placement, Ltd.,
 Washington, D.C.
photo: Ricardo Barros

Déjeuner Déjà Vu, detail [3]
Courtesy Sculpture Placement, Ltd.,
 Washington, D.C.
photo: Ricardo Barros

Déjeuner Déjà Vu, detail [4]
Courtesy Sculpture Placement, Ltd.,
 Washington, D.C.
photo: Ricardo Barros

Déjeuner Déjà Vu [5]
life-sized cast bronze
Grounds For Sculpture, Hamilton, New Jersey
Courtesy Sculpture Placement, Ltd.,
 Washington, D.C.
photo: Ricardo Barros

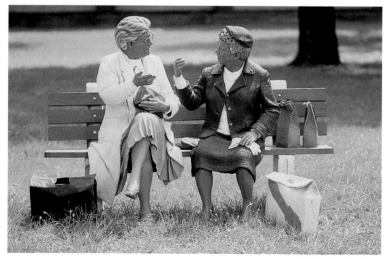

[1]

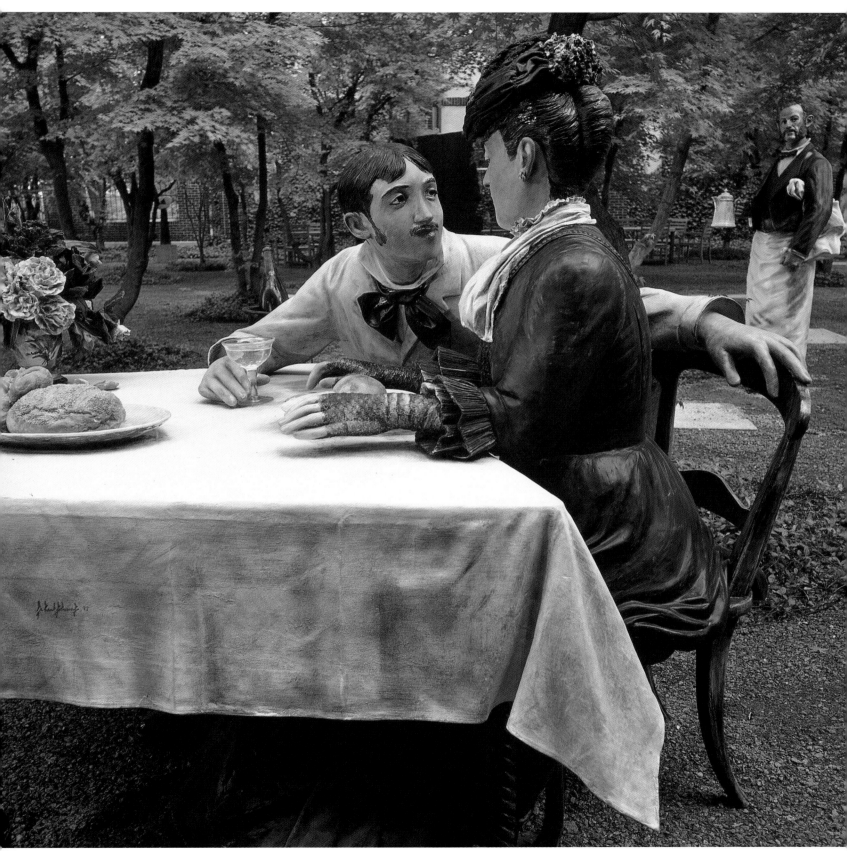

[2]

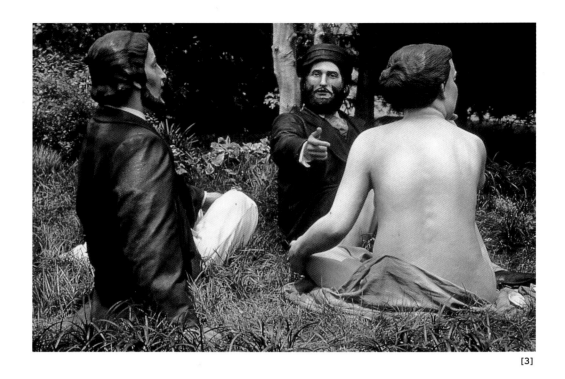

[3]

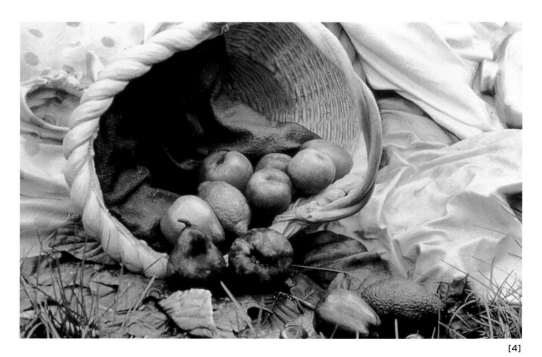

[4]

[5]

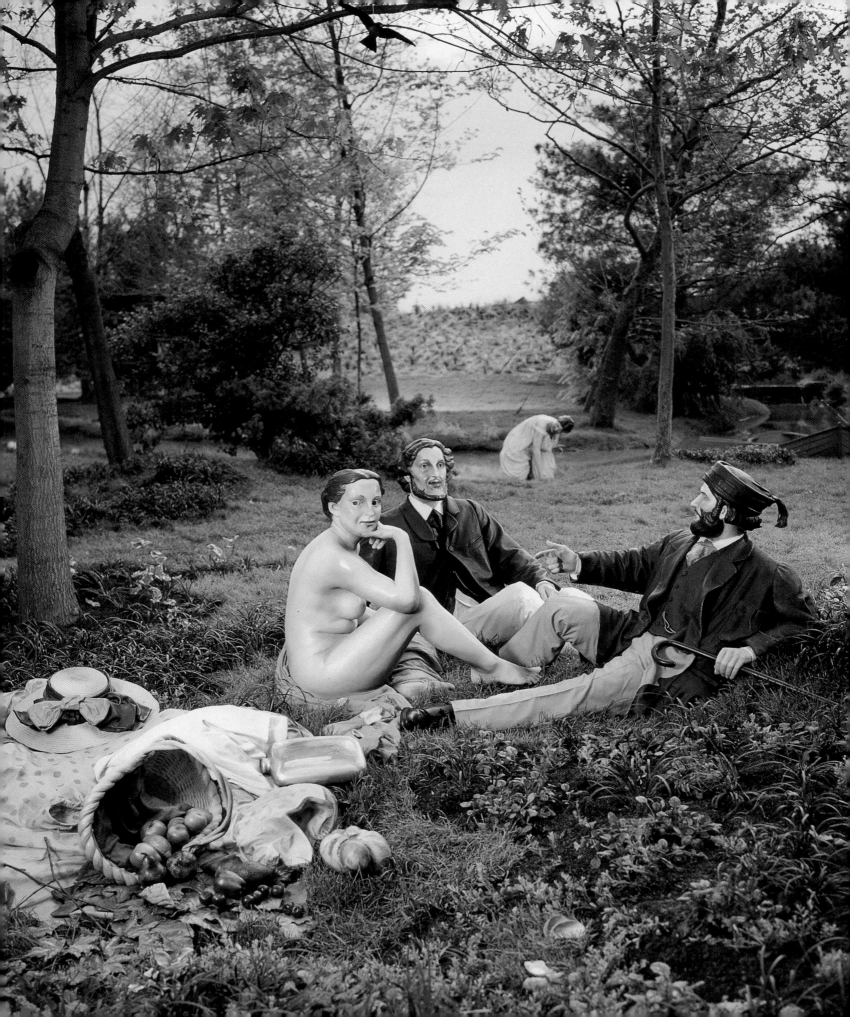

ANISH KAPOOR

The work of Anish Kapoor three-dimensionally illustrates his continual interest in the *void*—a concept often discussed in the fields of science, philosophy, and religion. Kapoor's outdoor sculpture projects become a type of mysterious, spiritual architecture created out of concrete and stucco. Related to his smaller interior sculptures of hollowed-out stones, the monolithic forms of these outdoor works draw the viewer into the structure. Whether block like or bell-shaped, with smooth surfaced, gently sloping sides, these massive objects encourage you to walk around and into them, experiencing both the outside and inside of the form, mass, and emptiness. The doorway slits and minimal openings appear as black holes from the outside, yet inside they create geometric forms of light on the chamber's walls and floor.

Anish Kapoor was born in Bombay, India in 1954, and lives and works in London. He has been exhibiting his work since 1974, with many worldwide, solo exhibitions to his credit, including shows at the 44th Venice Biennale, Italy; the Tel Aviv Museum of Art, Israel; and the 6th Japan Ushimado International Art Festival, Japan.

Descent into Limbo [1]
concrete, stucco
19' 6" x 19' 6" x 19' 6" (5.9 m x 5.9 m x 5.9 m)
Project for Documenta IX, Kassel, Germany
Courtesy the Artist and Lisson Gallery, London
photo: Dirk de Neef, Ghent

Descent into Limbo, detail [2]
Courtesy the Artist and Lisson Gallery, London
photo: Dirk de Neef, Ghent

Building for a Void [3]
concrete, stucco
height: 49' (14.9 m)
Project for Expo '92, Seville, Spain
Courtesy the Artist and Lisson Gallery, London
photo: John Edward Linden, London

Building for a Void, detail [4]
Courtesy the Artist and Lisson Gallery, London
photo: John Edward Linden, London

Building for a Void, detail [5]
Courtesy the Artist and Lisson Gallery, London
photo: John Edward Linden, London

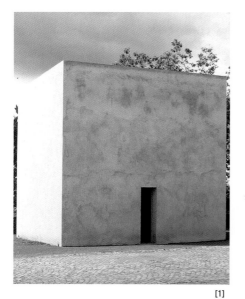

[1]

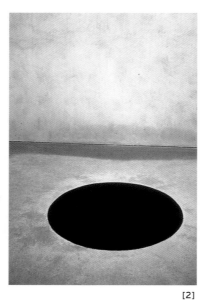

[2]

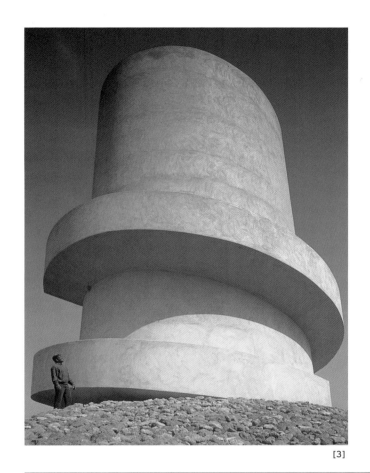

[3]

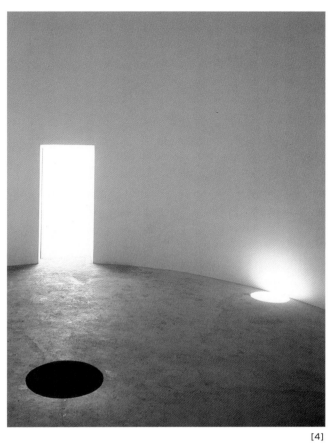

[4]

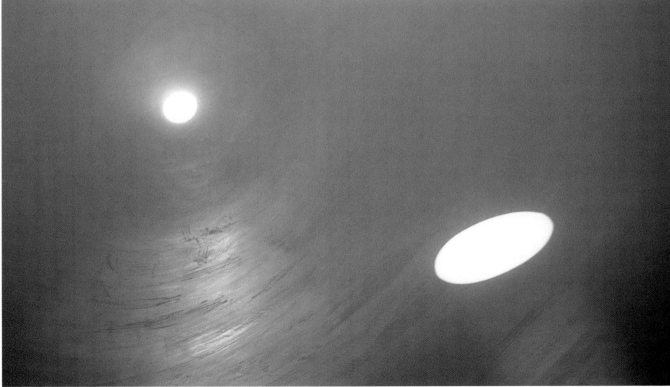

[5]

LILA KATZEN

Born in Brooklyn, New York in 1932, Lila Katzen has been creating abstract sculpture since the early 1960s. Early in her career she created site-specific installations incorporating light, culminating with the 65-foot sculpture *Liquid Tunnel* for the 1970 Sao Paulo Biennale. She was among the first American artists to be concerned with space concepts and motifs, exhibiting crater proposals entitled *Moon Markers* in 1968, and was designated by NASA as an official NASA artist.

Katzen's work evolved into monumental outdoor installations during the past two decades. She was invited to participate in Monumenta, the first Monumental Sculpture Invitational in the United States. Her interest is in the union of sculpture with architecture and the site, incorporating historical and archaeological concerns, both factual and mythological. Just as important to this artist is the relationship of the sculpture to human scale and human interaction. Her signature work utilizes rolling, ribbon-like curves of Cor-ten steel, brushed stainless steel, or bronze, frequently embellished with emblematic welded lines that become a form of hand writing with metal. The large, outdoor works are formed with industrial presses and rollers after the composition has been finalized through the creation of *maquettes* or models.

Katzen has held nearly one hundred solo exhibitions in the United States and abroad. Her work is included in many public collections: the National Gallery of Art, Washington, D.C.; the Museum of Fine Art, St. Petersburg, Florida; and the Baltimore Museum of Art, Maryland; as well as corporate and private collections.

Favorite Graces [1]
textured stainless steel
12' x 10' x 2' 6" (3.7 m x 3 m x .8 m)
Ulrich Museum, Wichita, Kansas
photo: Lila Katzen

Butterfly [2]
kinetic sculpture, textured and mirrored stainless steel
6' 6" x 5' x 1' 6" (2 m x 1.5 m x .5 m)
Collection of Mr. and Mrs. Martin Sosnoff
photo: Gretchen Tatge

Wand of Inquiry [3]
rolled, polished and hand-textured stainless steel with Cor-ten steel seating at base
19' x 10' x 10' (5.8 m x 3 m x 3 m);
 10' x 10' x 10' (3 m x 3 m x 3 m)
Brandeis University, Waltham, Massachusetts
photo: Lila Katzen

Aqua Libra [4]
stainless steel, textured with bronze weldments
8' x 3' 7" x 3' 4" (2.4 m x 1.1 m x 1 m)
Grounds For Sculpture, Hamilton, New Jersey
photo: Ricardo Barros

Flotenescort [5]
concrete, aluminum
19' x 19' x 3' (5.8 m x 5.8 m x .9 m)
The Peter Rodino Building, Newark, New Jersey

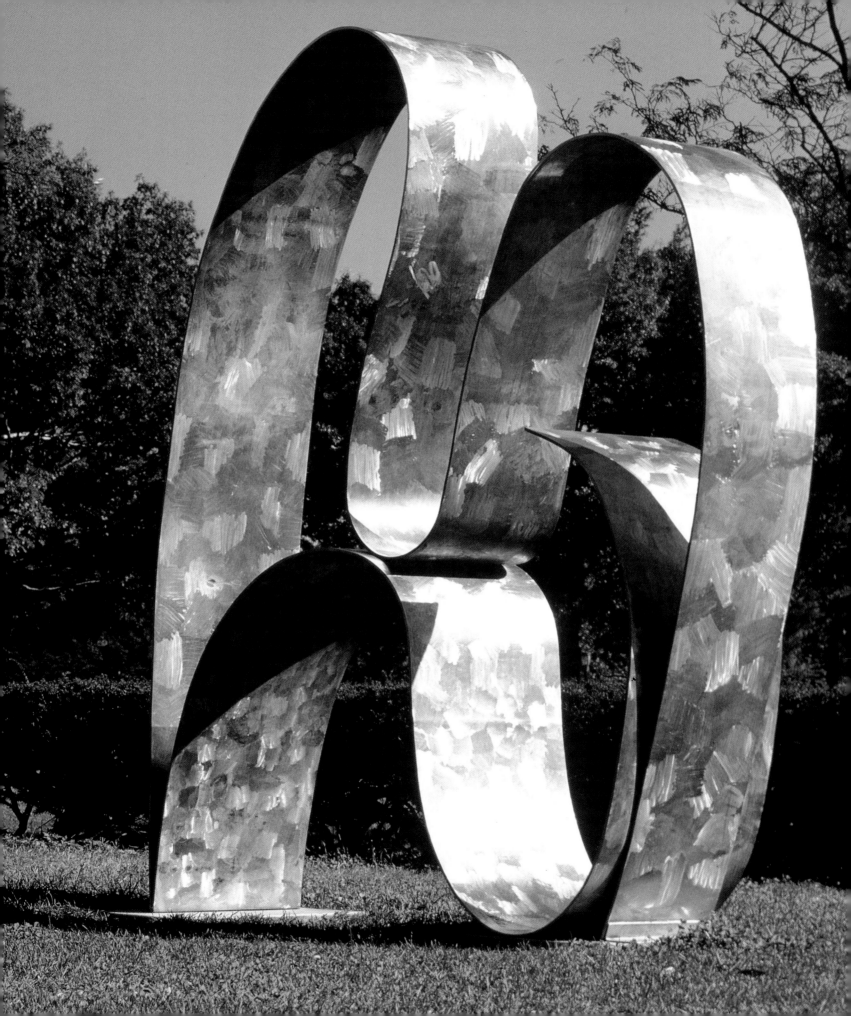

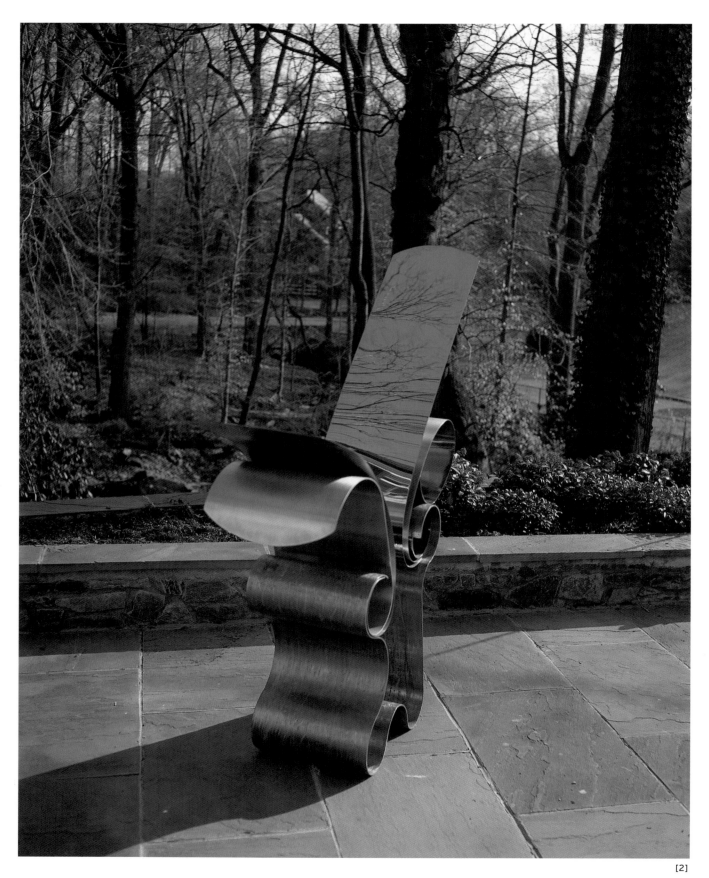

[2]

[3]

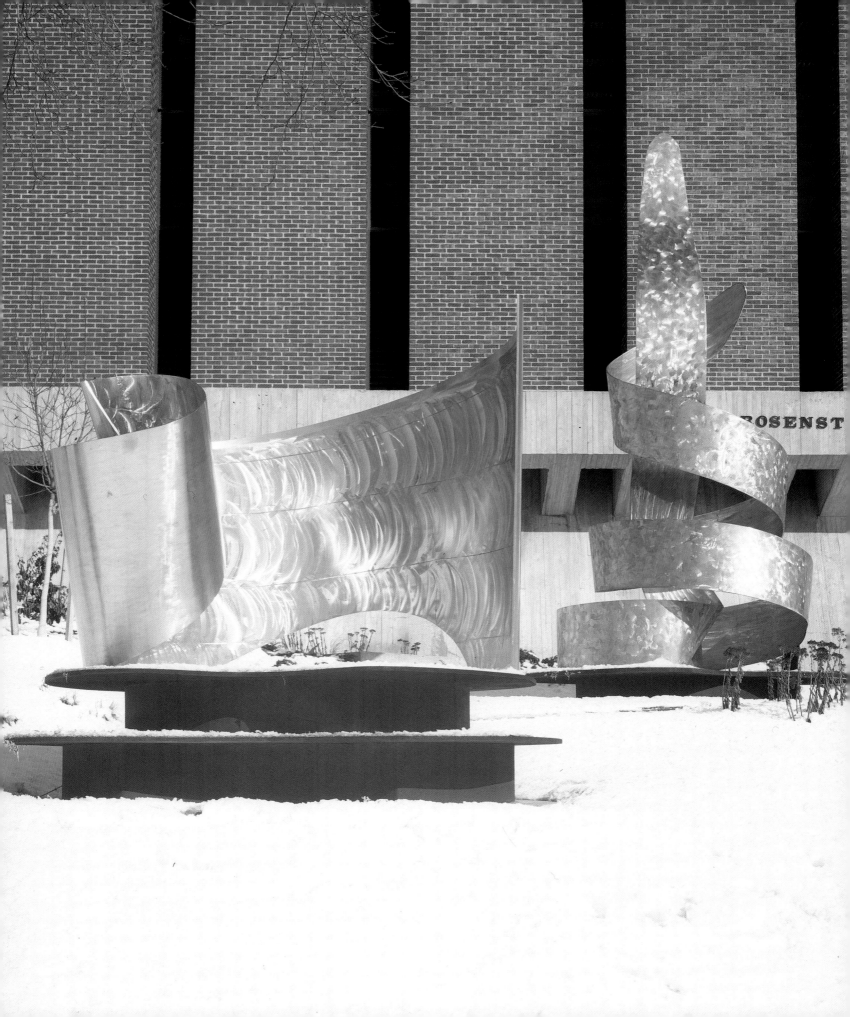

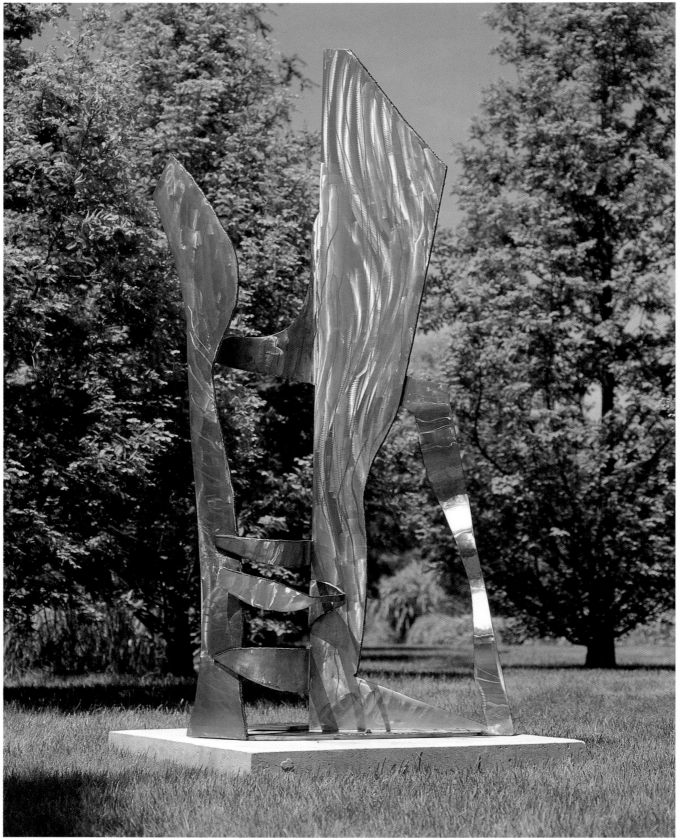

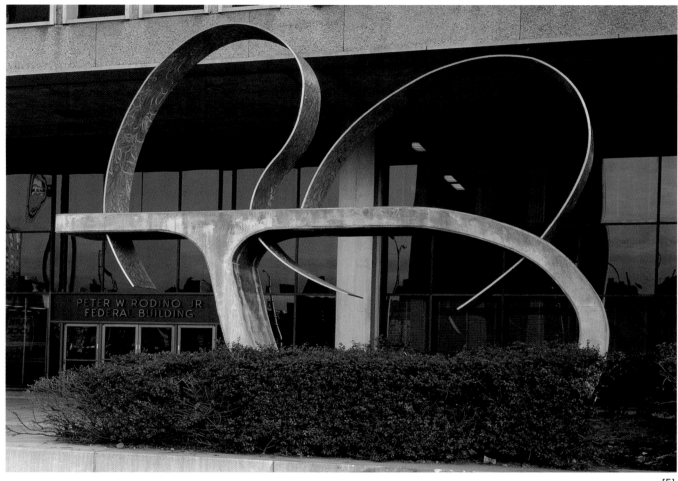

MEL KENDRICK

Mel Kendrick, known for his sculptural objects in wood, has cast a number of his works in bronze. This is a necessity for his large-scale commissions that are placed outdoors. The bronze, while underscoring the artifice of the material, also clarifies the texture and emphasizes the lines on the surface of the sculpture.

As in *Black Trunk*, Kendrick's sculptures are often made from a single piece of wood that is cut up with a chain saw and reconstructed. The saw acts, in a way, as a drawing tool, allowing the artist to create forms that shift from geometric to organic, with gestures of his body. In *Black Trunk*, the holes are in the form of a traditional dovetail joint, used to hold two pieces of wood together. However, in this instance they are completely superfluous.

Born in Boston, Massachusetts in 1949, Kendrick has been exhibiting his work since 1974 in over thirty one-person exhibitions and many more group shows. His sculpture can be found in numerous public collections, including the Storm King Art Center, Mountainville, New York; Centro Cultural Arte Contemporaneo, Mexico City, Mexico; and the Australian National Gallery, Canberra, Australia.

Black Trunk [1]
bronze
9' 8" x 4' 11" x 4' 4" (2.9 m x 1.5 m x 1.3 m)
Grounds for sculpture, Hamilton, New Jersey
photo: Ricardo Barros

Sculpture No. 4 [2]
bronze
8' 7" x 5' 8" x 5' 8" (2.6 m x 1.8 m x 1.8 m)
Toledo Museum of Art, Toledo, Ohio; Gift of the
 Apollo Society
©Mel Kendrick 1991, 1994

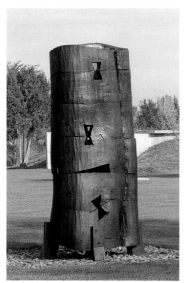

[1]

WILLIAM KING

William King has worked throughout his career in a wide range of mediums, including vinyl and other fabrics, wood, terra-cotta, bronze, steel, and aluminum. He began to produce his trademark aluminum figurative sculptures in the late 1960s. These flattened and elongated, towering people are often depicted interacting with each other, holding hands or interlocking limbs. They are precariously balanced on extremely thin legs, and from certain views the figures can disappear into abstraction. Sometimes, King's personages are shown in quiet moments of introspection, signified by a revealing pose or gesture. Their simplicity and movement give a feeling of gentle humor and friendship, or at times, satire. King is an astute observer of the human condition and creates in his large public sculpture a lightness and delicacy that contradict its dimension.

Born in Jacksonville, Florida in 1925, William King has exhibited his work in nearly forty solo exhibitions. He has work in the collections of the Rose Art Museum, Brandeis University, Waltham, Massachusetts; the Hirshhorn Museum and Sculpture Garden, Washington, D.C.; the Los Angeles County Museum of Art, Los Angeles, California; and the Whitney Museum of American Art, New York, New York.

Stroll [1]
tube and plate aluminum
height: 30' (9.1 m)
South Street Pedestrian Bridge, Philadelphia,
 Pennsylvania
photo: Ricardo Barros

Stroll, view 2 **[2]**
photo: Ricardo Barros

Cop [3]
Cor-ten steel
height: 18' (5.5 m)
South Dade Police Station, Miami, Florida

Vision [4]
one-inch aluminum plate
height: 36' (11 m)
Mozart Development Corporation,
 Mountainview, California

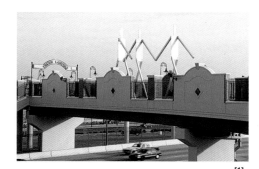

[1]

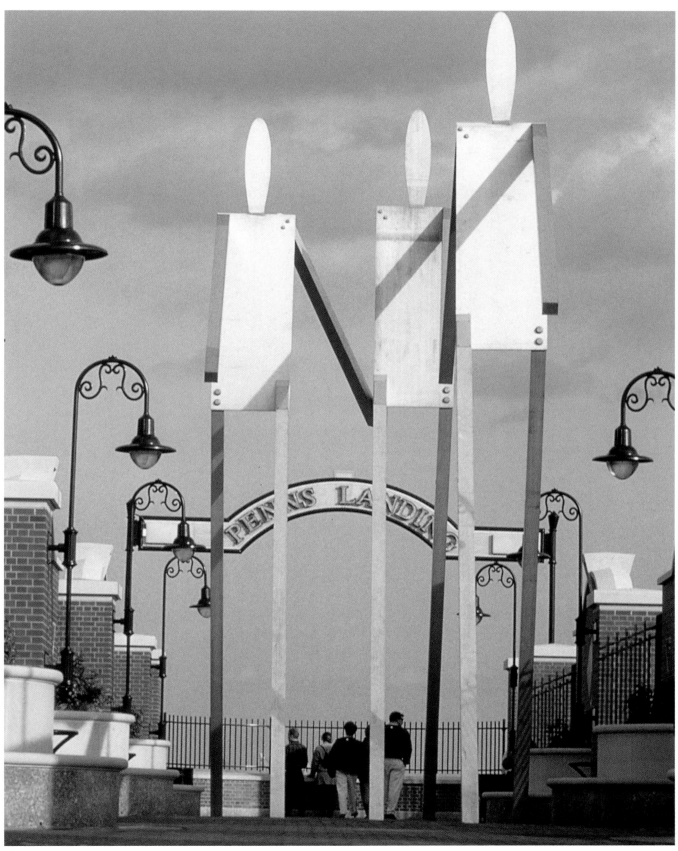

[2]

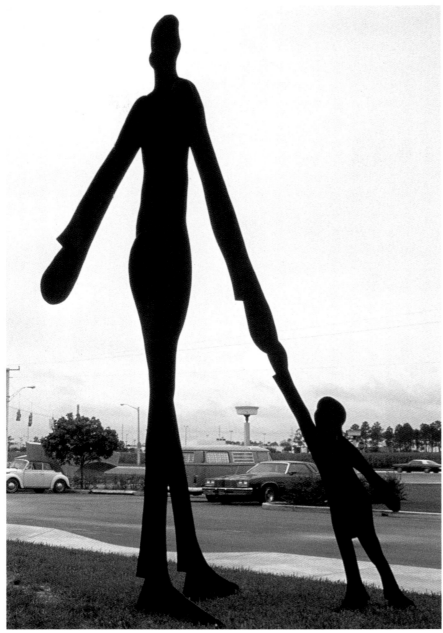

[3]

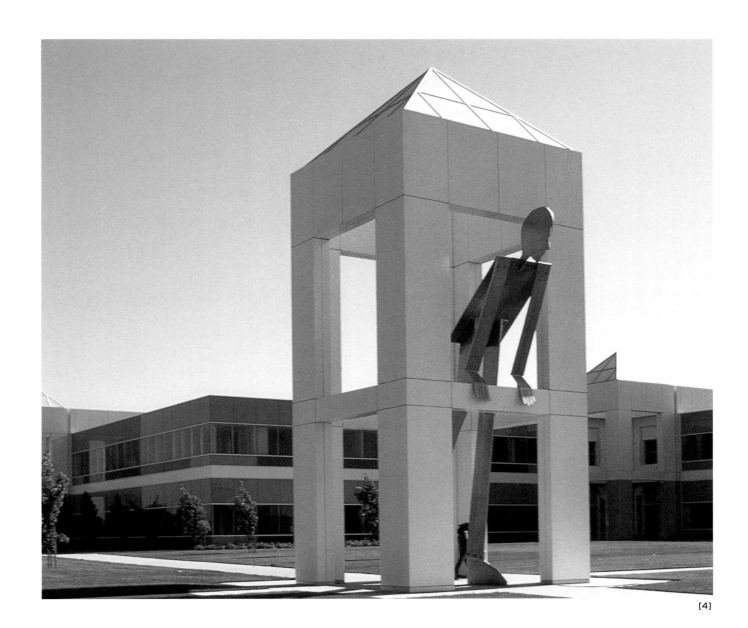

[4]

GRACE KNOWLTON

"My work is about inner spaces, and the surrounding surfaces which define them."

Grace Knowlton

Originally a painter, Grace Knowlton was born in Buffalo, New York in 1932. Since 1971 she has had sixteen solo exhibitions of her work throughout the United States, and three times as many group exhibitions. Her sculpture is represented in private, public, and corporate collections in the United States and abroad, including sites such as the Storm King Art Center, Mountainville, New York; the Museum of Outdoors Art, Denver, Colorado; and the Victoria and Albert Museum, London, England.

Knowlton's sculptures are primarily based upon an exploration of the sphere. Whether made from clay, ferro-concrete, copper, or mixed metals, her orbs impart an organic nature through their exposed seams and the natural weathering of their surfaces. Since the emergence of the circle on prehistoric cave walls and in petroglyphs, it has become the most important and widespread geometric symbol. Often used as an iconic sign for the sun, moon, or eye, Knowlton's spheres can be associated with planets, boulders, or eggs. They can also offer more ephemeral references to life, and time, as the circle is without beginning or end.

Painted Sphere [1]
Design Cast
diameter: 7' (2.1 m)
Socrates Sculpture Park, Long Island City,
 New York
photo: Grace Knowlton

Sentinels [2]
welded copper
8' x 4' x 4' (2.4 m x 1.4 m x 1.4 m)
Blue Hill Cultural Center, Pearl River, New York
photo: Grace Knowlton

Clay Spheres [3]
clay
diameter: 9"–3' (.2 m–.9 m)
Patrick Lannan Collection
photo: Grace Knowlton

Spheres [4]
ferro-concrete
diameter: 3"–8' (.9 m–2.4 m)
Storm King Art Center, Mountainville, New York
photo: Grace Knowlton

[1]

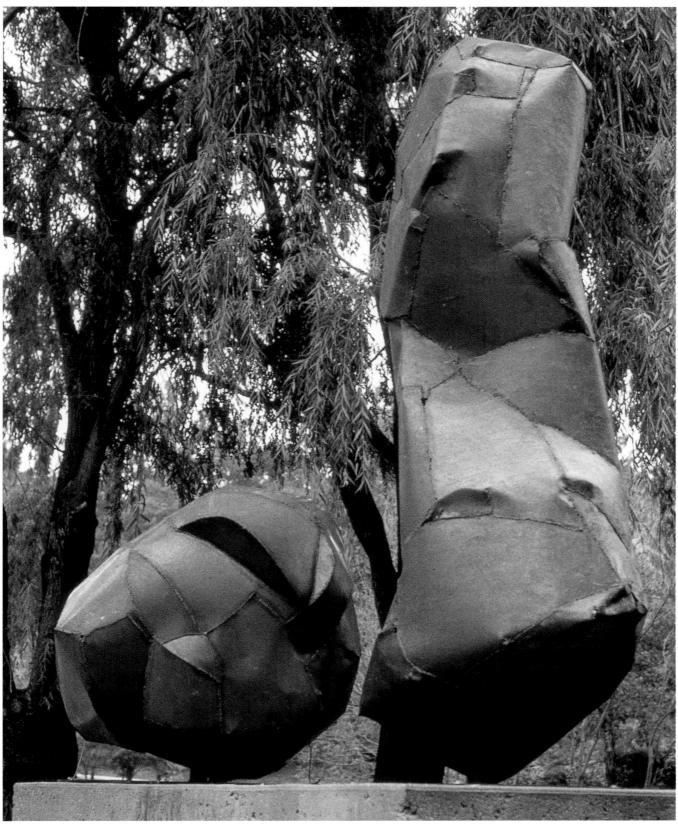

[2]

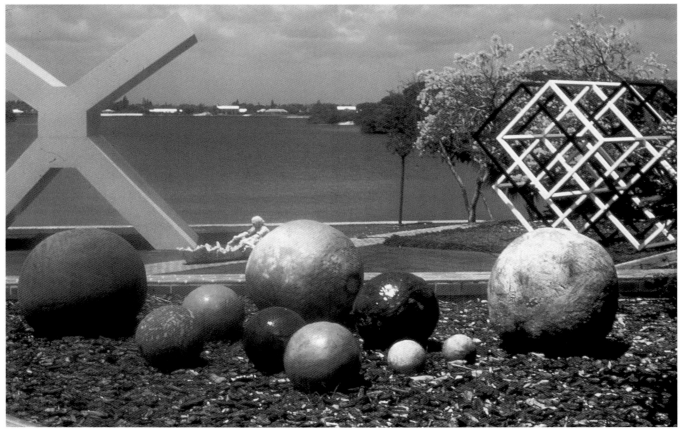

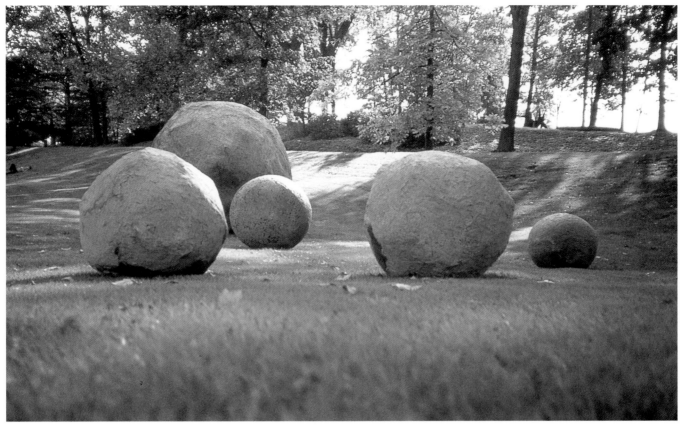

[4]

ALEXANDER LIBERMAN

Born in Kiev, Russia in 1912, Alexander Liberman lived in London and Paris before moving to New York City in 1941. With nearly sixty solo exhibitions of painting and sculpture to his credit, and more than twice as many group shows, Alexander Liberman is represented in public collections worldwide. Among them are: DeCordova Museum and Sculpture Park, Lincoln, Massachusetts; Hakone Open-Air Museum, Kanagawa, Japan; Laumeier Sculpture Park, St. Louis, Missouri; and the Whitney Museum of American Art, New York, New York. Liberman is also a noted photographer and author.

Fabricated from cut-and-welded tubular steel elements, his monumental sculptures are frequently painted a vibrant red. The sliced, elliptical elements seem tenuously attached as they propel themselves outward and upward into space. Their delicate balance belies their weight and mass. Liberman's bold sculptures live in stark contrast to their surroundings.

Galaxy [1]
painted steel
27' x 44' x 12' (8.2 m x 13.4 m x 3.7 m)
Oklahoma City, Oklahoma

Adam [2]
painted steel
28' 6" x 29' 6" x 24' 6" (8.7 m x 9 m x 7.5 m)
Collection of Storm King Art Center,
 Mountainville, New York

Olympic Illiad [3]
painted steel
45' x 60' x 45' (13.7 m x 18.3 m x 13.7 m)
Seattle, Washington

Above [4]
painted steel
25' x 12' x 12' (7.6 m x 3.7 m x 3.7 m)
Collection of Economic Laboratory, Osborn
 Building Plaza, St. Paul, Minnesota

Mananaan [5]
steel
26' x 24' 6" x 16' 5" (7.9 m x 7.5 m x 5 m)
Collection of University of Illinois, Urbana
Photo taken at Top Gallant Farm, Pawling,
 New York

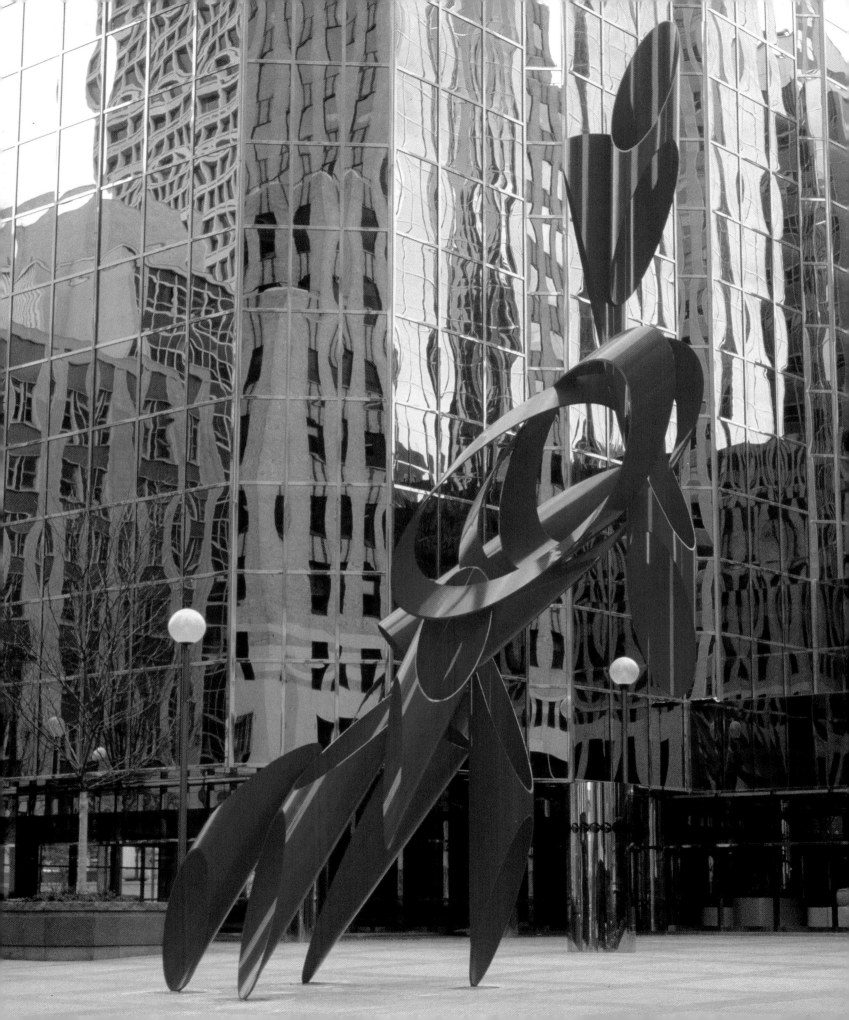

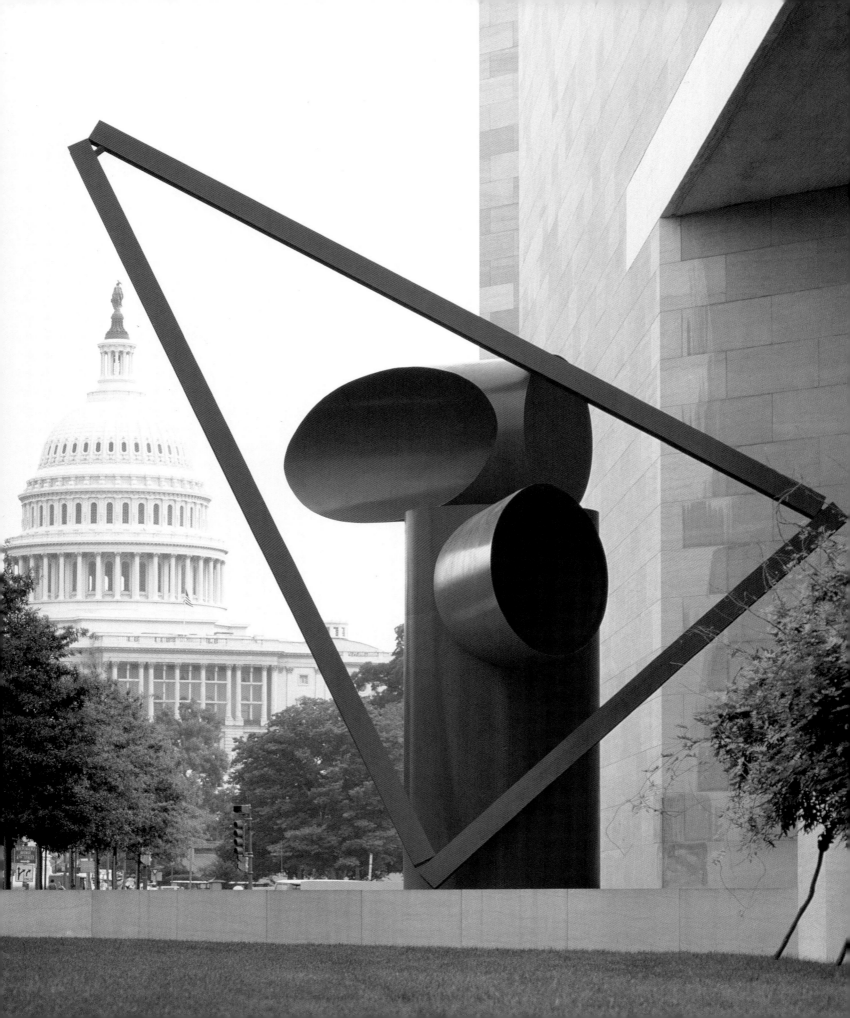

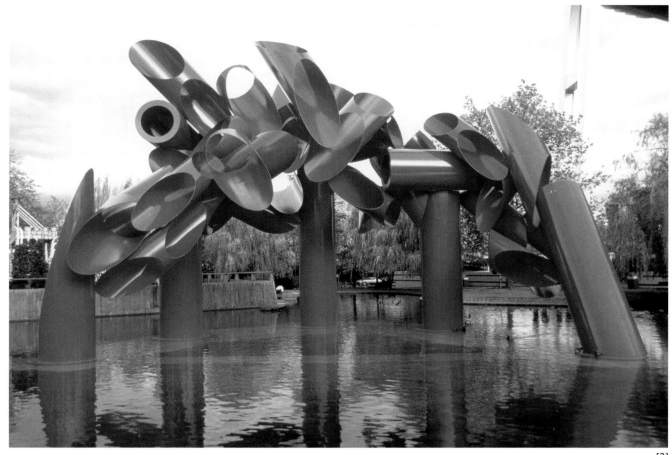

[3]

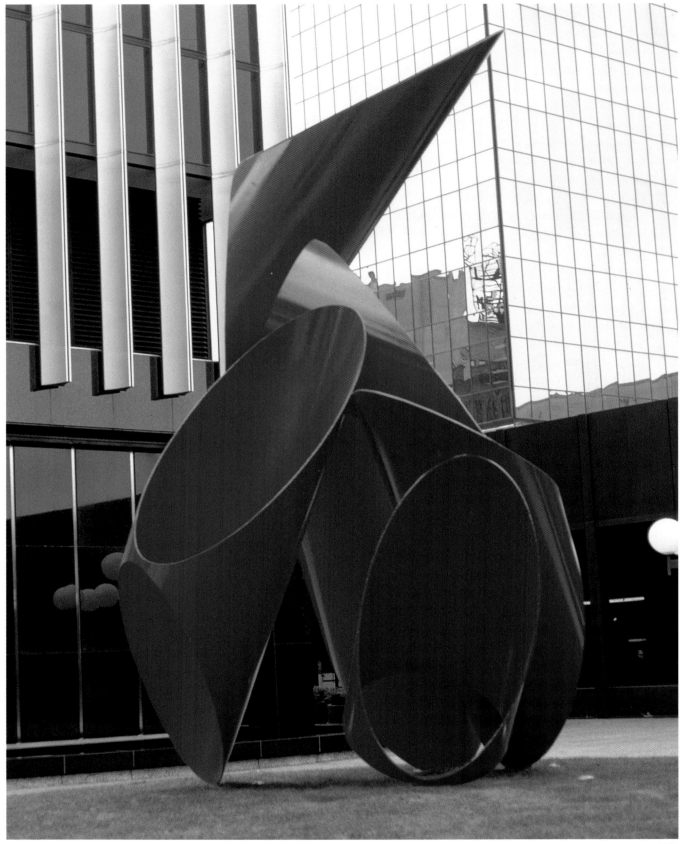

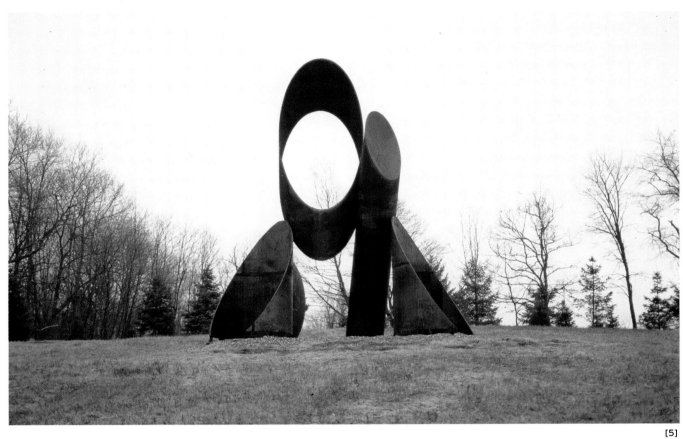

CLEMENT MEADMORE

"My intention is to create geometric sculpture with the intensity of the best modeled and carved sculpture of the past . . . I have three goals: one is to explore geometry's expressive potential. The second is to make the whole sculpture comprehensible from any viewpoint. The third goal is to avoid the feeling of a front and back. These criteria are especially relevant in public spaces."

Clement Meadmore

The sculpture of Clement Meadmore possesses a dynamic energy and strength, capturing the viewer's attention through its powerful presence and it's changing nature when seen from multiple perspectives. Born in Melbourne, Australia in 1929, by the mid 1960s Meadmore had begun evolving the sculptural language for which he is widely known. Monumental works in steel, aluminum, and bronze twist and turn with a flexibility that belies their materials. Meadmore's work animates its space with a tension that comes from the outward and upward-thrusting masses, cantilevering into space. Although the artist initially creates small models, he envisions them as outdoor sculptures destined for a public site.

Meadmore's sculpture can be found worldwide in well over fifty public collections, including the Corcoran Gallery of Art, Washington, D.C.; the National Gallery, Canberra, Australia; and the Adachi Outdoor Sculpture Collection, Japan.

Upbeat [1]
aluminum
31' x 22' x 13' (9.4 m x 6.7 m x 4 m)
MEPC American Properties, The Colonnades, Dallas, Texas
photo: C. Meadmore

Portal [2]
bronze
7' 6" x 6' 3" x 4' 6" (2.3 m x 1.9 m x 1.4 m)
Kaosiung Museum of Fine Arts, Kaosiung, Taiwan
photo: C. Meadmore

Terpsichore [3]
bronze
8' 4" x 12' x 7' (2.5 m x .3 m x 2.1 m)
Collection of Mr. and Mrs. John Conway, Conway, Massachusetts
photo: K. Baker-Carr

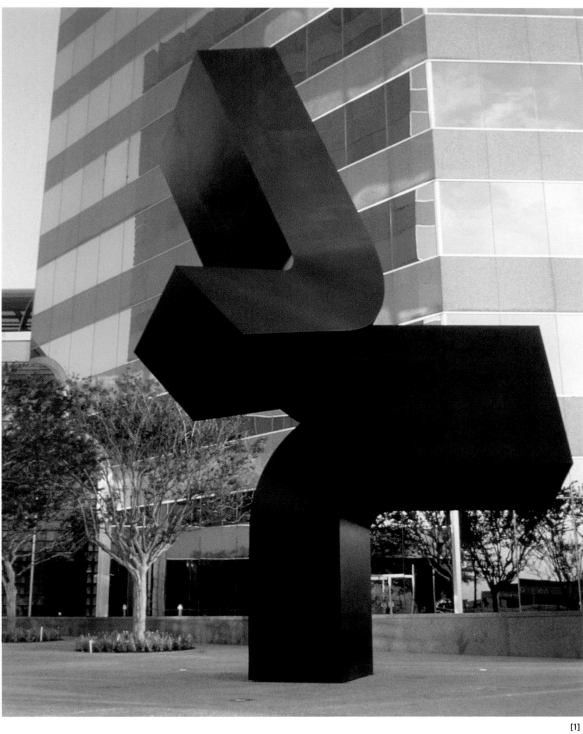

[1]

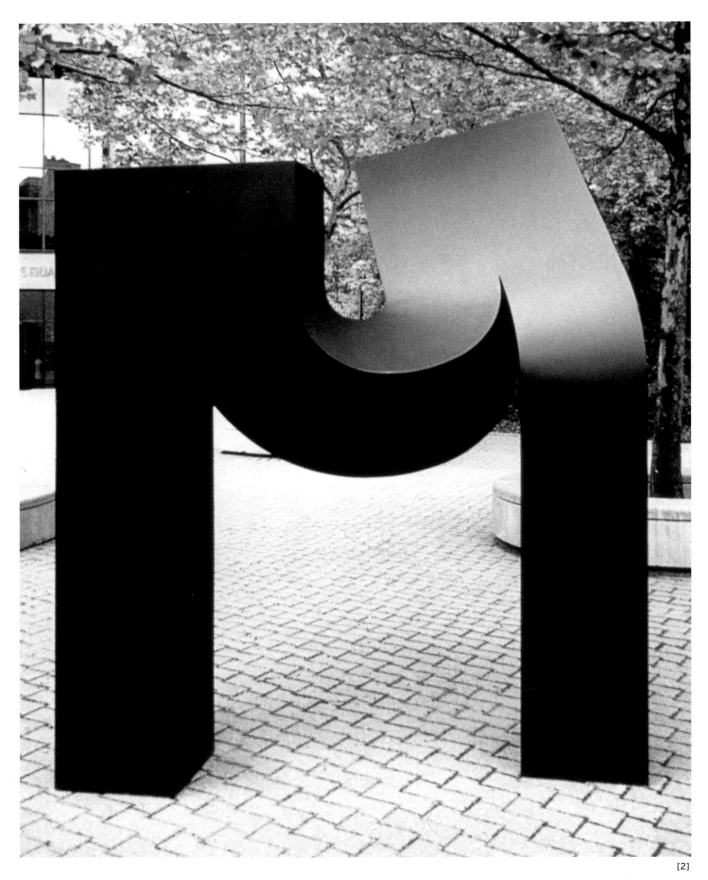

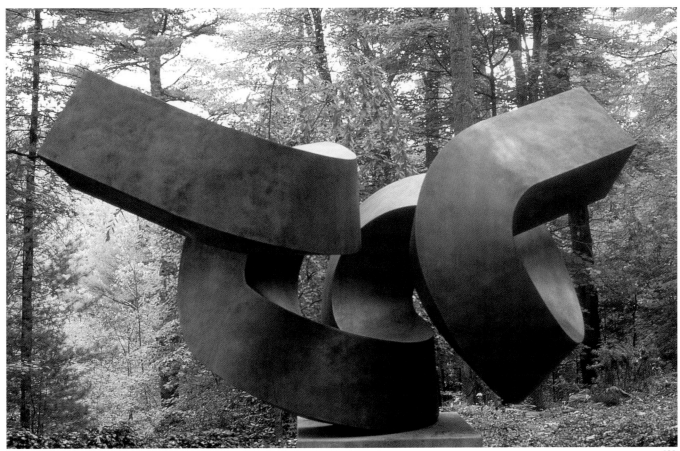

MARY MISS

Born in New York City in 1944, since 1968 Mary Miss has completed nearly thirty projects in the United States and abroad. Her sculpture often employs structures such as walkways, fences, and viewing pavilions that are incorporated into the natural elements of a site. Her works simultaneously function as works of art, parks, classrooms, recreational facilities, and landscape-restoration projects. Tracing the various paths through one of her works, the viewer becomes the vehicle that laces together the experience of the place—the link between the built and the natural, the site's past and future uses.

Greenwood Pond: Double Site is a project completed by Miss in 1996 in the center of Des Moines, Iowa. Before beginning this project, Greenwood Pond was a derelict and neglected site. Miss reconfigured it into a place that is inviting, accessible, and educational. A series of paths lead the visitor to multiple views of the site: a walkway overhanging the edge of the pond allows you to move out over the water; a ramp takes you down to the level of the pond. The line of the ramp extends in an arc across the pond and is marked by wood pilings and a trough cut in the water. Adjacent to this is a pavilion, mound, series of trellis structures, stone terraces, and plantings of prairie and wetland grasses. Miss' site-specific sculpture works in harmony with nature and is completed by the public, by the visitors who come to see and interact with it.

Greenwood Pond: Double Site [1]
6.5 acres (2.63 hectares)
Des Moines, Iowa
photo: Assassi Productions

Greenwood Pond: Double Site, view 2 [2]

Greenwood Pond: Double Site, view 3 [3]

Greenwood Pond: Double Site, view 4 [4]

Greenwood Pond: Double Site, view 5 [5]

[1]

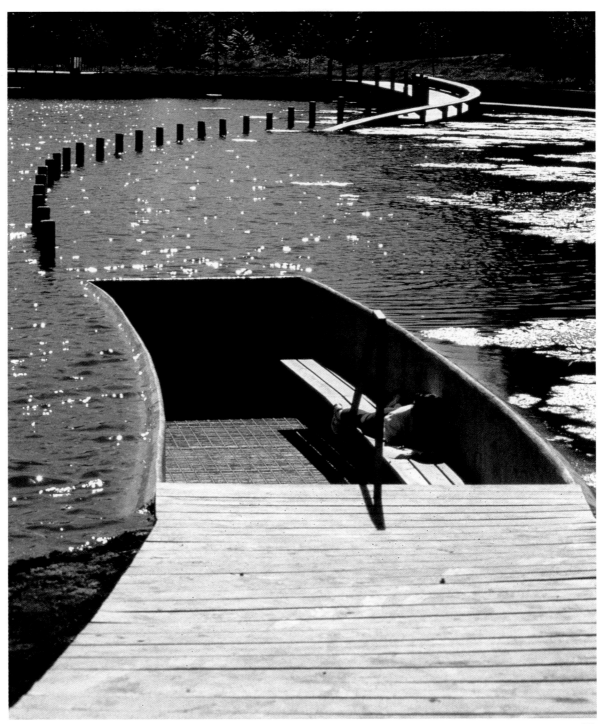

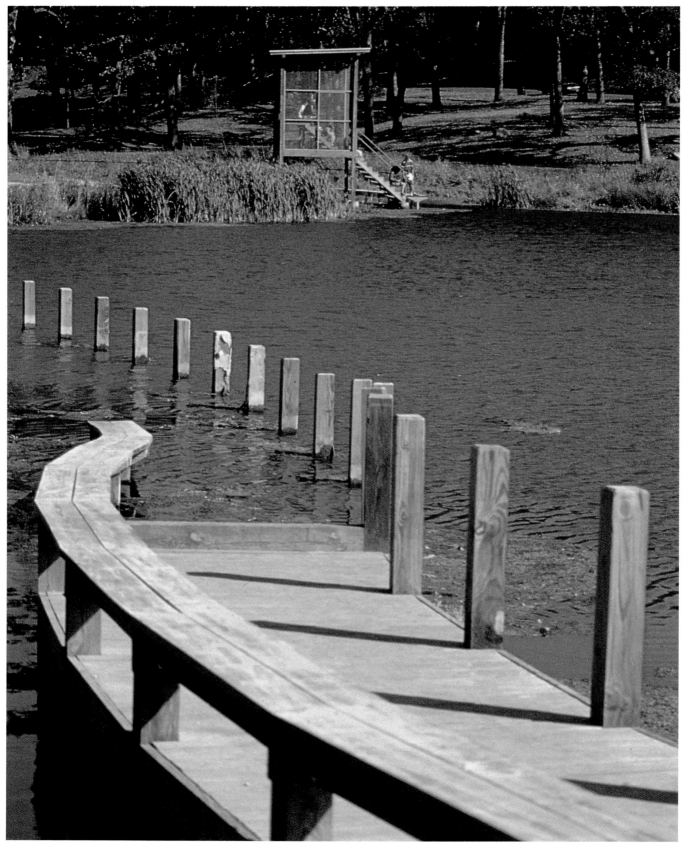

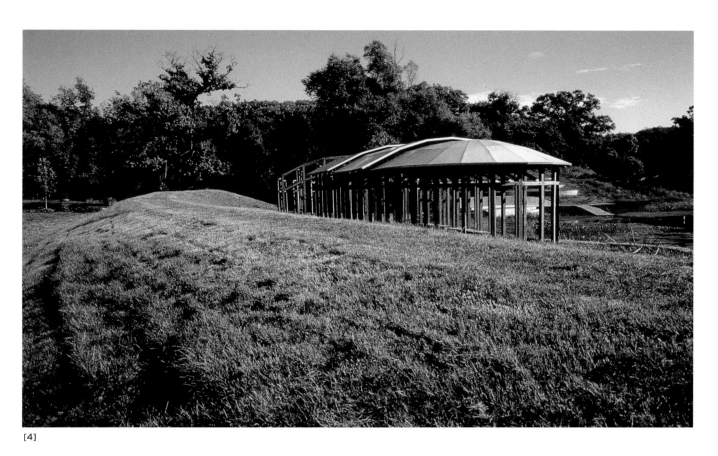

[4]

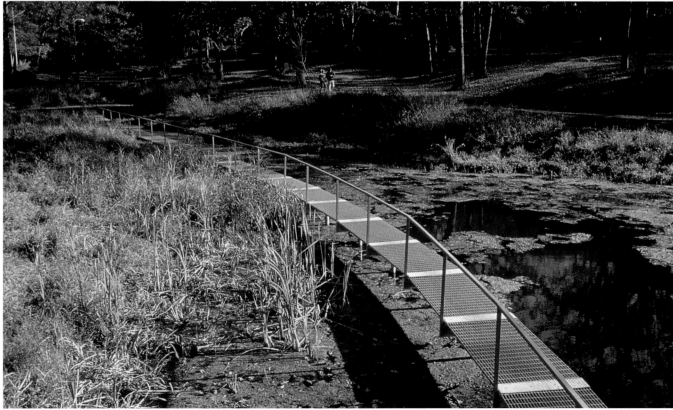

[5]

JESÚS BAUTISTA MOROLES

"Part of what I attempt with my sculpture is to bring the quarry into the gallery—to make the stone important by drawing attention to it, and to show the finished piece as the result of its interaction with its context. The stone itself is the starting point. I always choose pieces that already suggest their final form. By working directly in response to the character of the stone, I hope to expose the truth of the material."

Jesús Bautista Moroles

In beginning a sculpture, Jesús Bautista Moroles follows the inclinations of the stone. He drives wedges into the raw granite and allows it to create its own fissure. After working in the stone quarries of Carrara, Italy in 1979–1980, where nature and man have worked for centuries, he subsequently produced the monolithic sculptural forms for which he is known. The dichotomies of nature and man, chance and control, scale and surface detail are evident in Moroles' sculpture. A number of his public sculptures incorporate water and seating, creating an environmental installation that provides a comfortable, contemplative site and enables the viewer to interact with the work.

Jesús Bautista Moroles was born in Corpus Christi, Texas in 1950. His work has been exhibited in more than two hundred exhibitions nationwide, and is included in almost seventy collections, such as the Edwin A. Ulrich Museum of Art, Wichita State University, Wichita, Kansas; Fondazione Umberto Severi, Carpi, Italy; and the Museum of Contemporary Art, Osaka, Japan.

Stele Gateway [1]
Fredericksburg granite
15' 6" x 12' x 5' 8" (4.7 m x 3.7 m x 1.8 m)
Dallas Morning News, A. H. Belo Corporation,
 Dallas, Texas
photo: Craig Kuhner

Granite Gardens [2]
Texas premier rose granite
height: 5'–11' (1.7 m–3.4 m)
Birmingham Botanical Gardens, Birmingham,
 Alabama
photo: Phillip Morris

Moonscape Ring [3]
Texas pink granite
5' 2" x 5' 3" x 22" (1.6 m x 1.6 m x .5 m)
Core Bench
Texas pink granite
1' 11 1/2" x 2' 9" x 2' 9" (.5 m x .8 m x .8 m)
Molcajete
Texas pink granite
2' x 5' 3" x 5' 2" (.6 m x 1.6 m x 1.6 m)
BMC Software, Inc., Houston, Texas
photo: Ann Sherman

Granite Gardens, view 2 [4]
photo: Phillip Morris

Lapstrake [5]
Sardinian granite
22' x 12' x 4' (6.7 m x 3.7 m x 1.2 m)
E. F. Hutton, CBS Plaza, New York, New York
photo: Laurie Steiner

Houston Police Officers Memorial [6]
Texas granite, earth, grass, water
23' x 120' x 120' (7 m x 36.6 m x 36.6 m)
Houston, Texas
photo: Ann Sherman

Texas Wedge Fountain [7]
Texas premier rose granite
height: 9' 4" (2.8 m)
photo: Ann Sherman

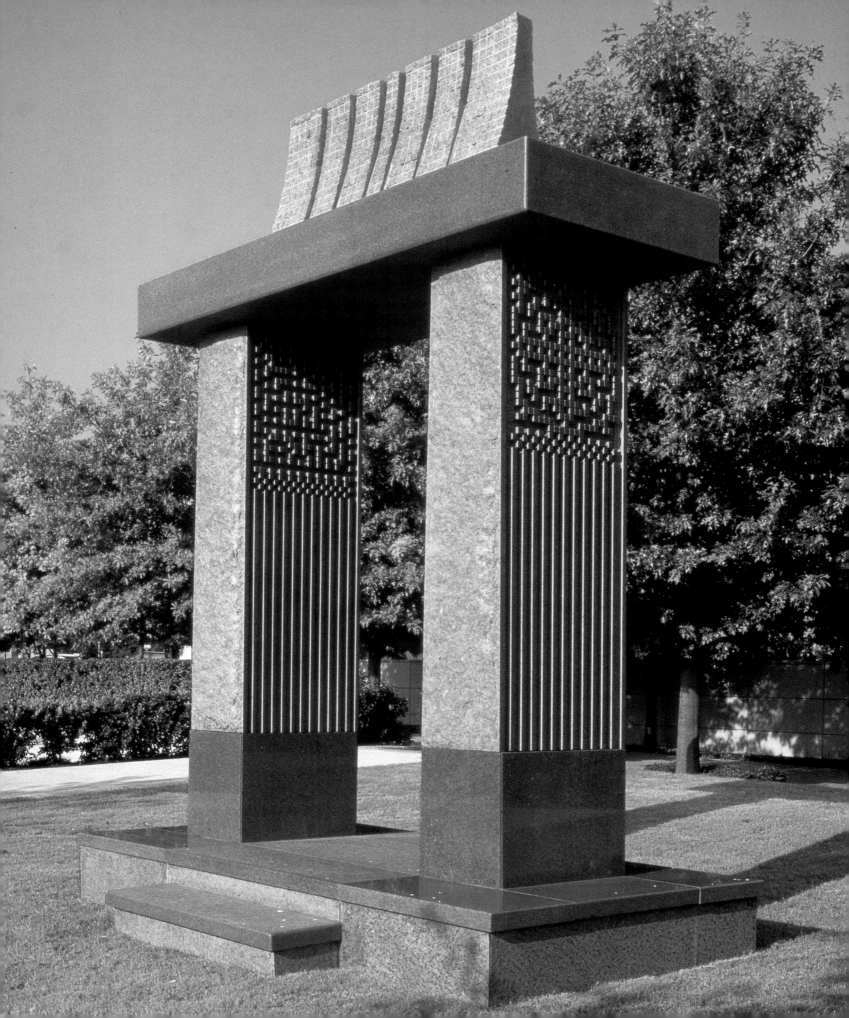

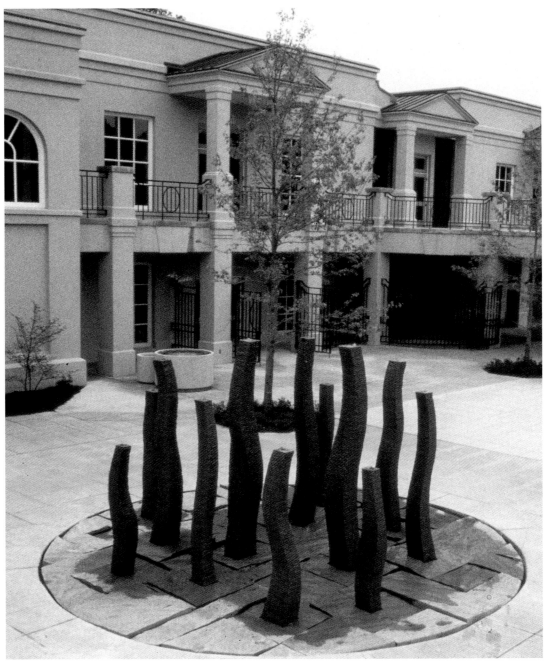

[3]

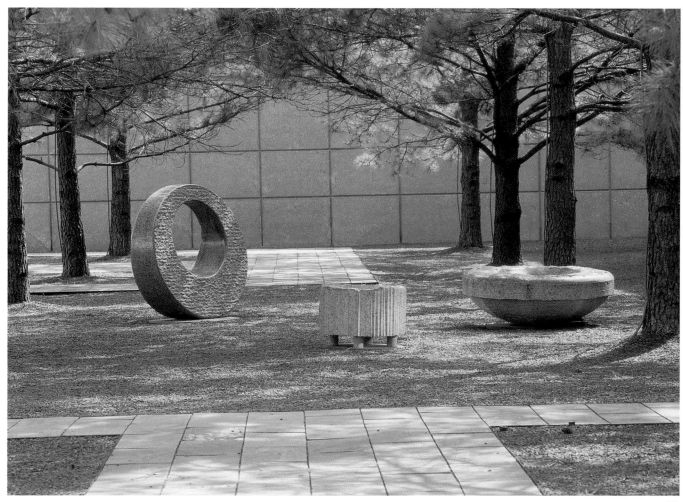

[3]

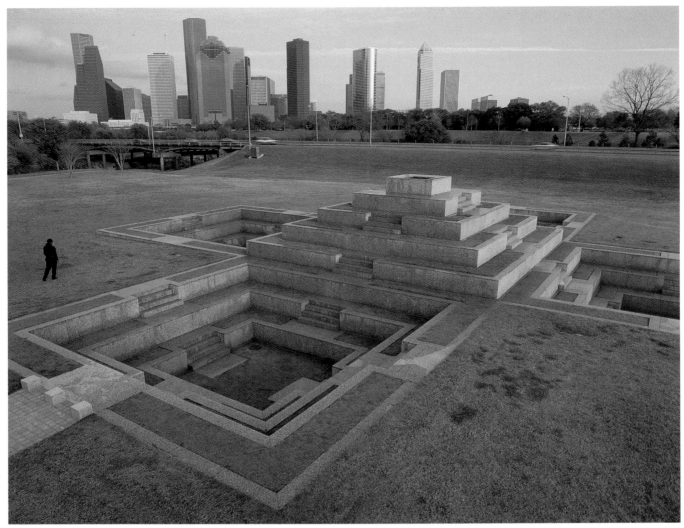

[4]

[5]

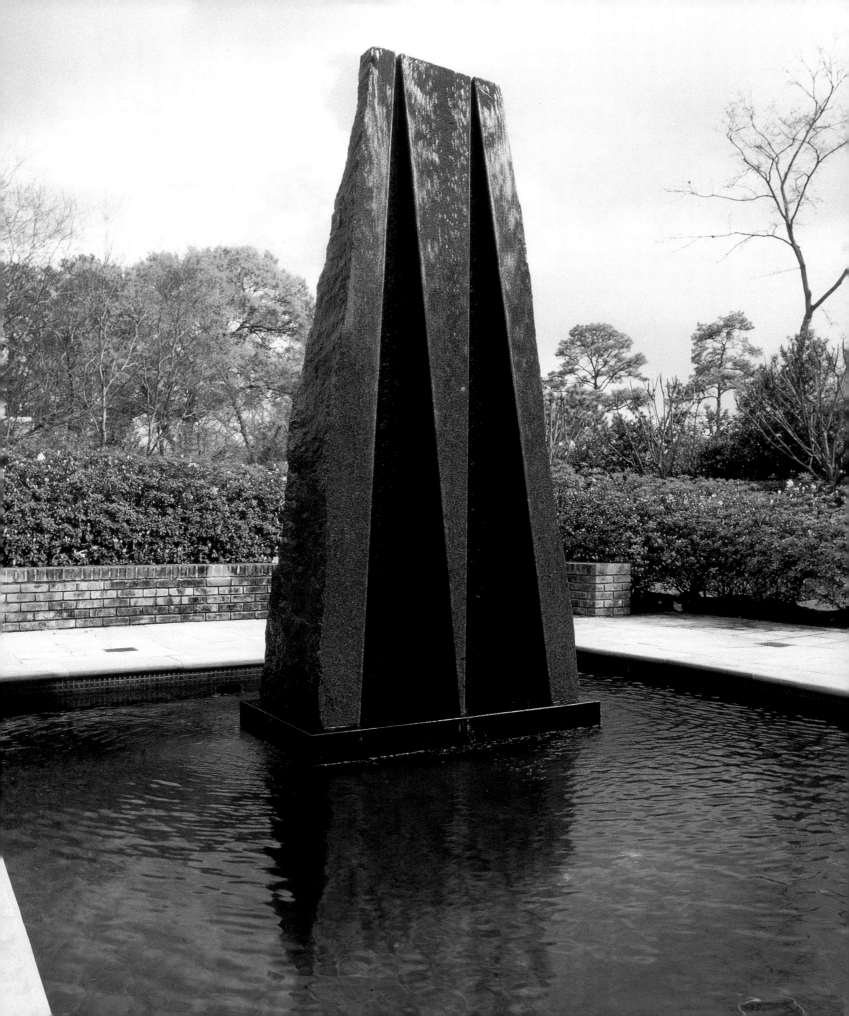

ROBERT MURRAY

Robert Murray is well known for his large, nonrepresentational painted steel and aluminum sculpture. Murray's early training as a painter is evident in the attention he pays to the surface of the sculpture, his vibrant use of color, and in the forms themselves, which are derived from two-dimensional aluminum or steel plate. The metal has been cut, rolled, folded, and bent to create work that floats above the ground in a series of curves and wavelike undulations. But unlike a painting, the viewer must physically walk around the sculpture to appreciate the different aspects of the piece, which change dramatically from each angle of view.

Murray was born in 1936 in Vancouver, British Columbia, Canada, where he lived until 1960. He has been exhibiting his sculpture for more than 30 years, and was honored with a retrospective exhibition at the Reading Public Museum in Pennsylvania. Among other museums that contain his work in their collections are the Alaska State Museum, Juneau, Alaska; the Hirshhorn Museum and Sculpture Garden, Washington, D.C.; The National Gallery of Canada, Ottawa, Ontario; the Storm King Art Center, Mountainville, New York; and the Walker Art Center, Minneapolis, Minnesota.

Saginaw [1]
aluminum painted red
10' x 10' 11" x 3' 10" (3 m x 3.3 m x 1.1 m)
Delaware Art Museum, Wilmington, Delaware
photo: Robert Murray

Cumbria II [2]
two-inch steel plate painted cadmium yellow
15' x 15' x 30' (4.6 m x 4.6 m x 9.1 m)
University of British Columbia, Vancouver
photo: Robert Murray

Hillary [3]
painted aluminum
5' 8" x 15' 4" x 21' 4" (1.8 m x 4.6 m x 6.5 m)
Grounds For Sculpture, Hamilton, New Jersey
photo: Ricardo Barros

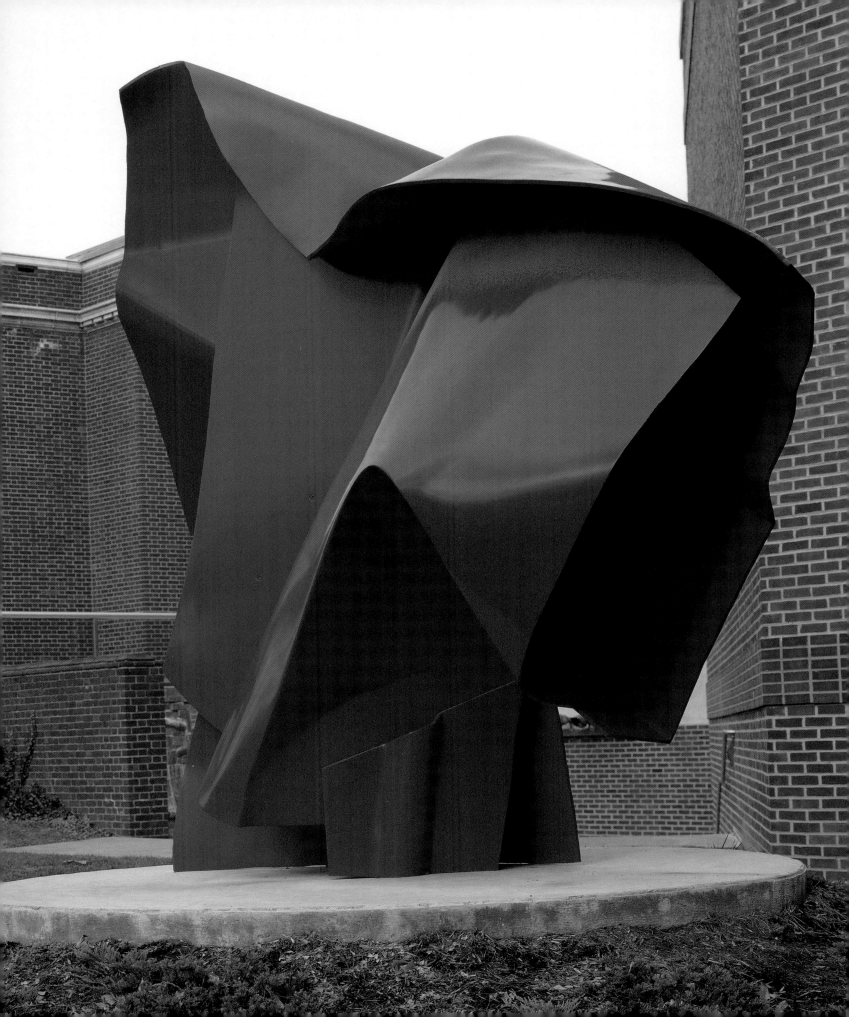

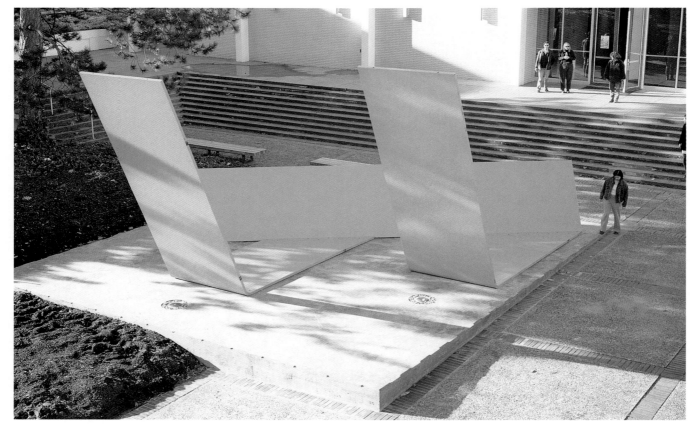

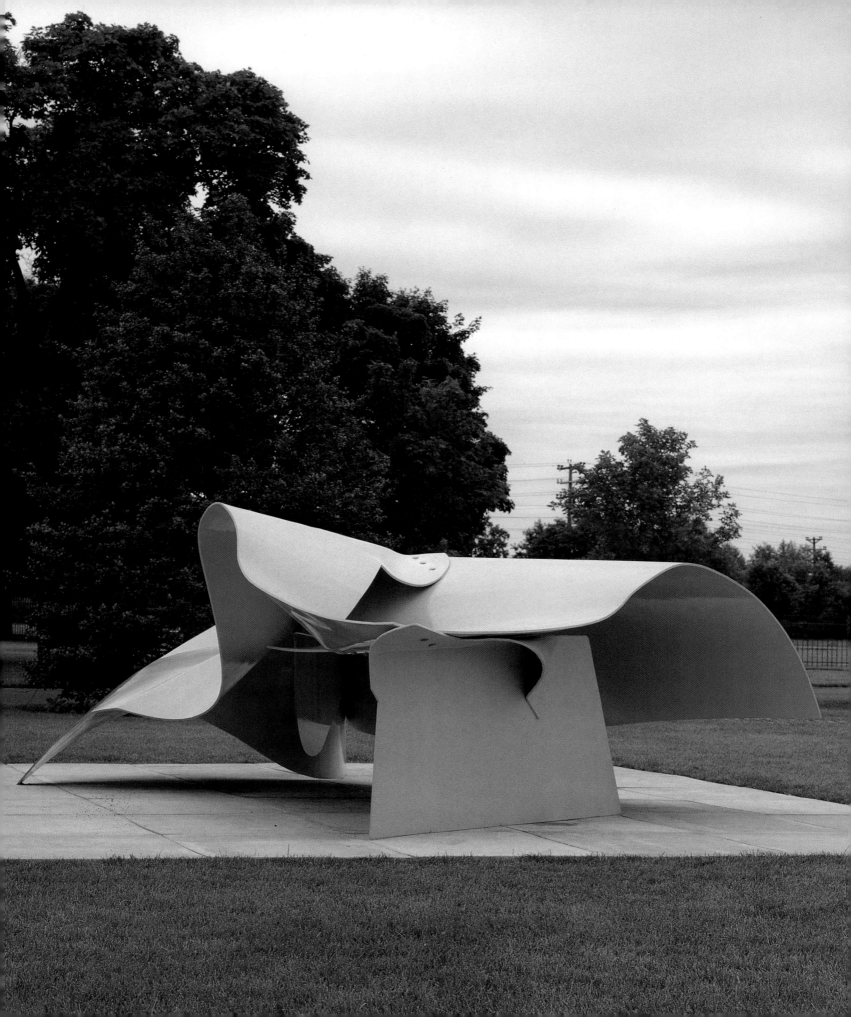

DENNIS OPPENHEIM

Dennis Oppenheim's career dates back to the late 1960s, when he made seminal contributions to the development of earth art, body art, and conceptual art. For the past several years, he has been exploring ideas for public sculpture and has realized several outdoor sculpture projects.

The idea for *Device to Root Out Evil* was developed in drawings and model form during 1996. When the plan for a new museum in the industrial section of Marghera, near Venice, Italy was put forth by the Venice City Council, Oppenheim was invited to show a selection of his sculpture. Previously a glass factory built in 1926, the new museum was renovated for the exhibition. It was decided that the outdoor work *Device to Root Out Evil* would be included in the exhibition, sited just outside the factory building.

Oppenheim interprets the church as an energized instrument, as described by the title. The partly skeletal church, two stories in height, pivots on the steeple, plunging forcefully into the ground. Ruby red Venetian glass shingles and green window glass were incorporated into the sculpture, allowing natural light and special night lighting to interact dramatically with it and the existing architecture. Its proximity to this building enhances the upside down nature of the work.

Dennis Oppenheim was born in Electric City, Washington in 1938, and in 1967 moved to New York. The artist has exhibited extensively in solo exhibitions worldwide. He is represented in well over one hundred public collections in the United States and abroad, such as ArtPark in Lewiston, New York; Fattoria di Celle, Pistoia, Italy; Laumeier Sculpture Park, St. Louis, Missouri; and Olympic Park, Seoul, South Korea.

Search Burst [1]
rolled steel, expanded steel, outdoor lights
12' x 6' x 6' (3.7 m x 1.8 m x 1.8 m)
P.S.1 Museum, New York, New York

Device to Root Out Evil [2]
*galvanized steel, anodized perforated
 aluminum, transparent red Venetian glass*
22' x 8' x 10' (6.7 m x 2.4 m x 3 m)
Installed at Pilkington S.I.V.,
 Marghera/Venice, Italy
Collection of Ginny Williams, Denver, Colorado
photo: Edward Smith, Venice

[1]

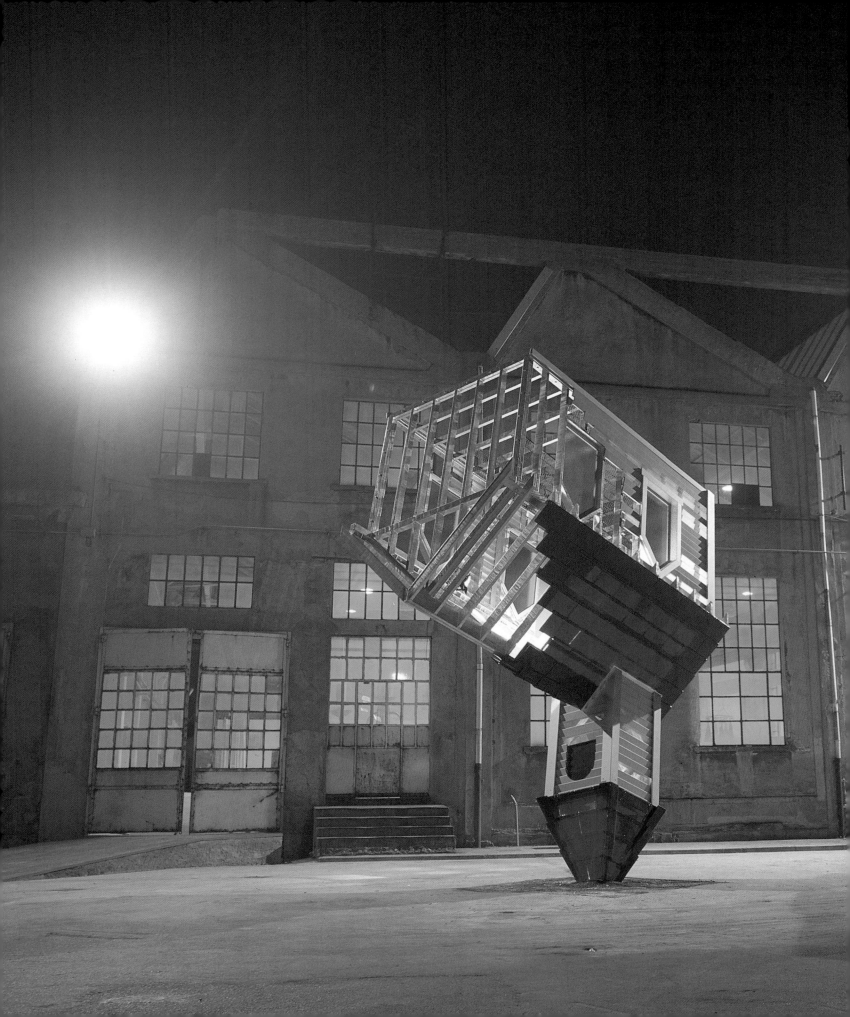

TOM OTTERNESS

Born in Wichita, Kansas, Tom Otterness began working as a public artist in 1978. He received his first major public commission in 1987 from the General Services Administration Art-in-Architecture program and produced a 300-foot-long cast-stone frieze, depicting his trademark, cartoon-like figures in various narrative settings. Since then he has completed ten public commissions in the United States and Germany, and has five more in progress. He has twenty-five solo exhibitions to his credit and is represented in public collections in the United States, The Netherlands, Israel, Spain, Japan, and Mexico.

Tom Otterness's sculpture is often integrated with architectural design and the landscape. His strange creatures are combinations of human and animal forms, and everyday objects. They speak to both children and adults, as can be seen in the playground he created for Battery Park City, New York, titled, *The Real World*. Completed in 1992, it consists of a trail of bronze footprints and pennies that unites numerous sculptures of figures, animals, and fairy-tale creatures.

[1]

The New World [1]
cast stone and cast bronze
300' (91.5 m) frieze, 2' (.6 m) high, on pergola
Edward R. Roybal Federal Building,
 Los Angeles, California; Commissioned by
 the General Services Administration, Ellerbe
 Beckott Associates, architects
Courtesy of Tom Otterness and Marlborough
 Gallery, New York, © Tom Otterness,
 1982–91
photo: Tom Vinetz

The Real World [2]
cast bronze, cast stone and aggregate
160' x 40' (48.8 m x 12.2 m)
Governor Nelson A. Rockefeller Park
 New York, New York; Commissioned by the
 Battery Park City Authority, Carr Lynch
 Associates, Inc., environmental design
Courtesy of Tom Otterness and Marlborough
 Gallery, New York, © Tom Otterness, 1992
photo: Richard Edelman

The Real World, detail [3]
Courtesy of Tom Otterness and Marlborough
 Gallery, New York, © Tom Otterness, 1992
photo: Richard Edelman

The Real World, view 2 [4]
Courtesy of Tom Otterness and Marlborough
 Gallery, New York, © Tom Otterness, 1992
photo: Richard Edelman

Marriage of Real Estate and Money [5]
cast bronze
Roosevelt Island, New York, New York;
 Commissioned by the Roosevelt Island
 Operating Corporation
Courtesy of Tom Otterness and Marlborough
 Gallery, New York, © Tom Otterness, 1996
photo: Oren Slor

Marriage of Real Estate and Money, view 2
(low tide) [6]
Courtesy of Tom Otterness and Marlborough
 Gallery, New York, © Tom Otterness, 1996
photo: Oren Slor

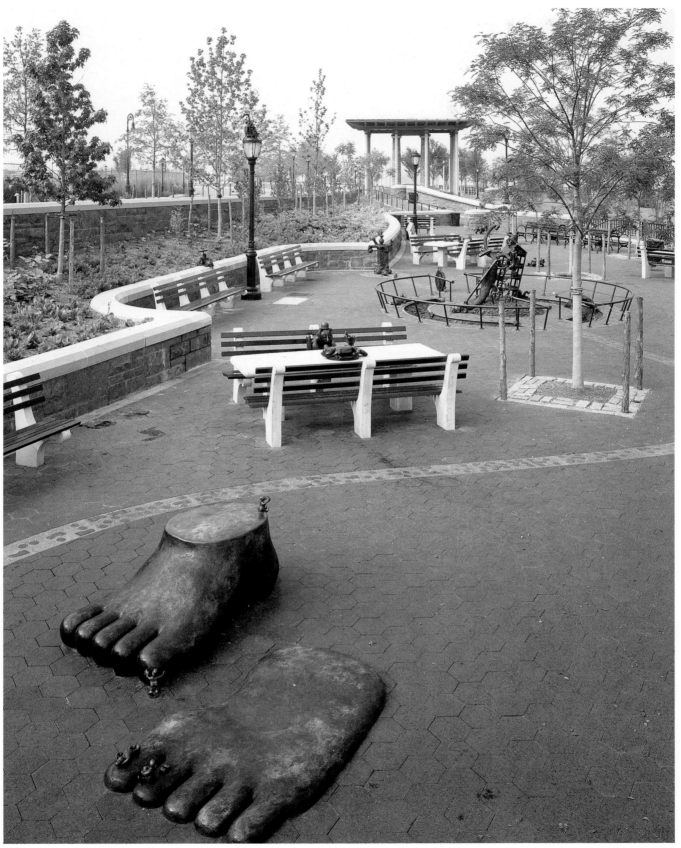

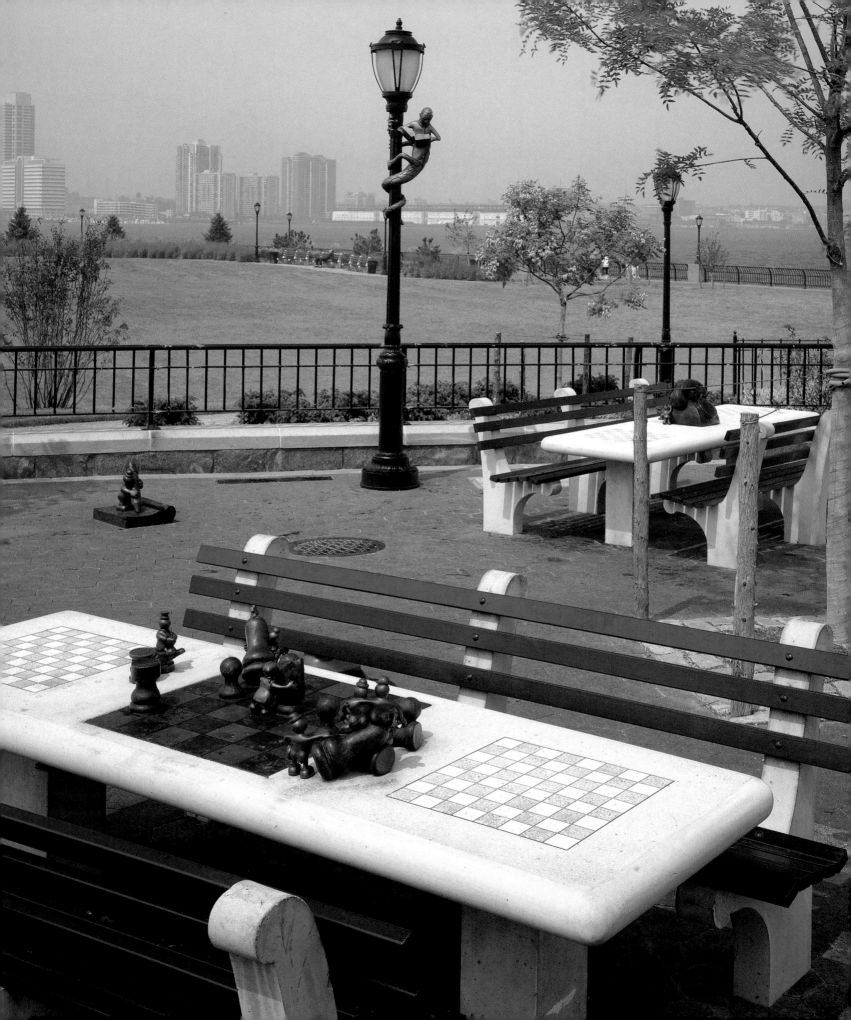

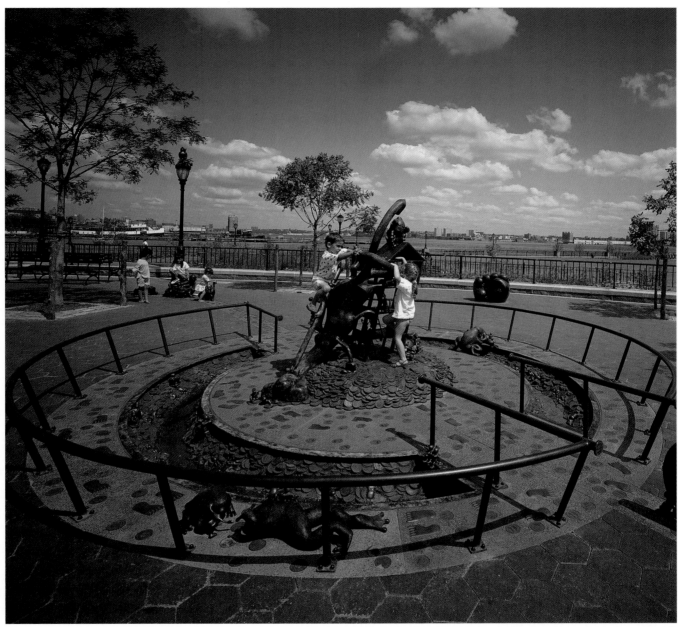

[4]

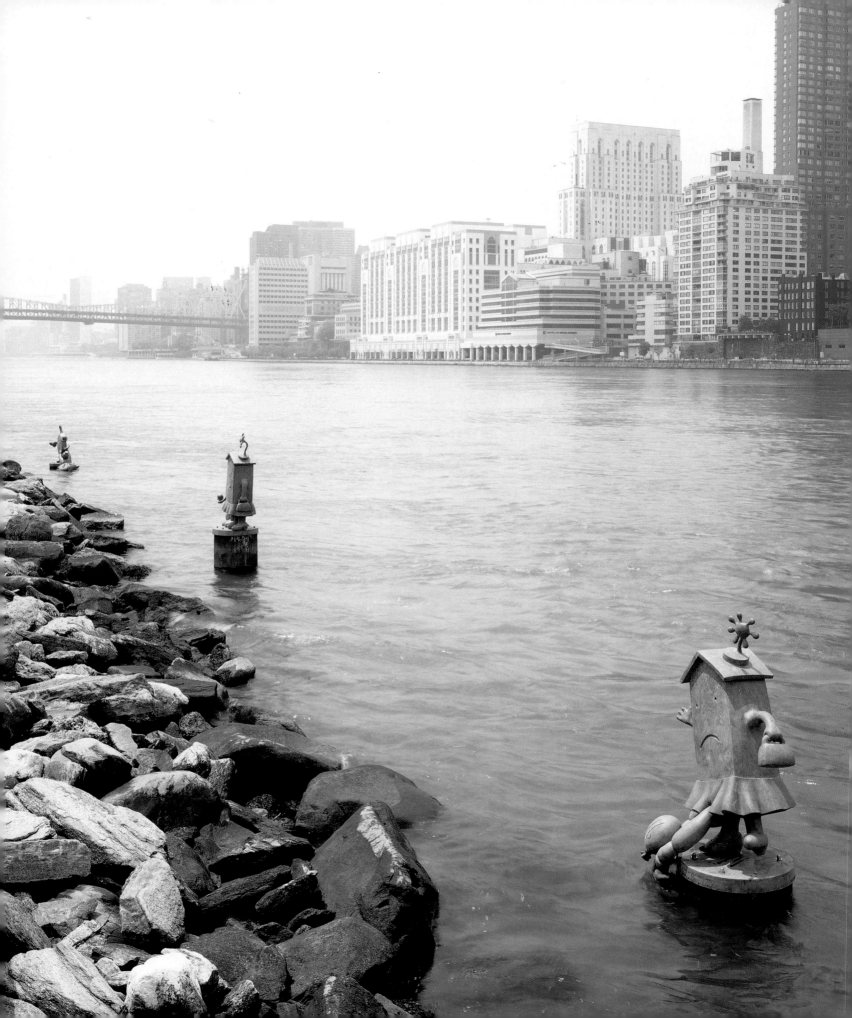

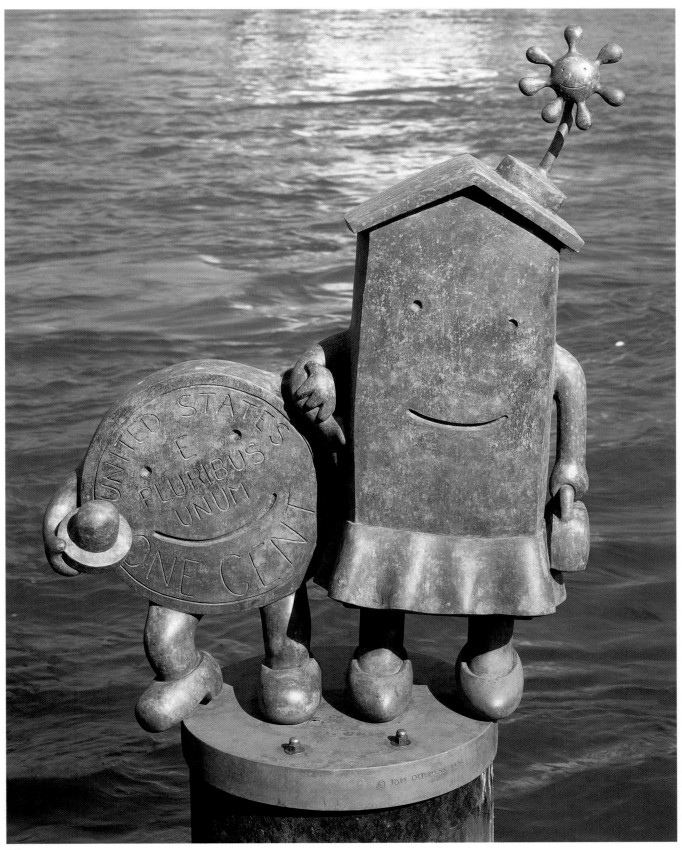

[6]

BEVERLY PEPPER

Beverly Pepper has received international recognition for her monumental sculpture, especially for works in cast iron. The artist often incorporates the surrounding site in her sculpture, with the earth becoming an integral component of the installation. Vertical, rusted, iron forms resemble oversized hand tools such as chisels and files. They also suggest columnar, architectural relics, particularly when placed in combination with carved out sections of the landscape.

Born in New York City in 1924, Pepper turned to creating sculpture in 1960 after painting for many years. In addition to a one-person show at the Metropolitan Museum of Art, she has had almost one hundred solo exhibitions and many group shows around the world. Public collections of the Hirshhorn Museum and Sculpture Garden in Washington, D.C. and Laumeier Sculpture Park in St. Louis, Missouri contain her sculpture, as do many international collections located in Sydney, Australia; Paris, France; Rehovath, Israel; and Florence, Italy.

Teatro Celle [1]
cast-iron elements
16' x 70' x 200' (4.9 m x 21.3 m x 61 m)
Villa Celle, Pistoia, Italy

Manhattan Sentinels [2]
four cast iron columns
height: 36–39' (11 m–11.9 m high)
Jacob K. Javits Federal Building, New York City

Teatro Celle, detail [3]

Shaped Memories (left) [4]
Beton fix, graphite, gesso
7' 2" x 4' 6" x 7' 2" (2.2 m x 1.4 m x 2.2 m)
Walls of Memory (right)
Beton fix, graphite, gesso
7' 4" x 4' 6" x 8' 1" (2.2 m x 1.4 m x 2.4 m)

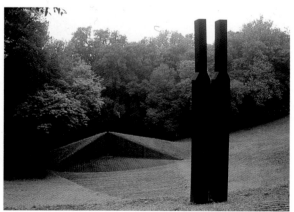

[1]

[2]

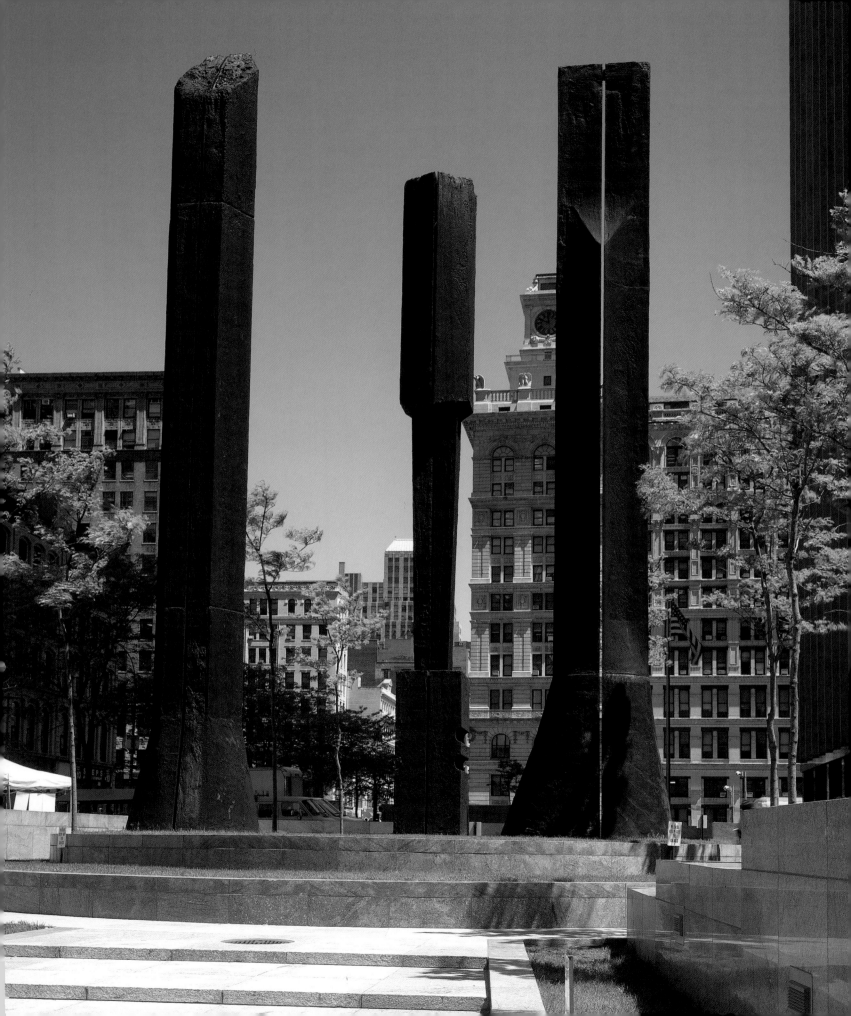

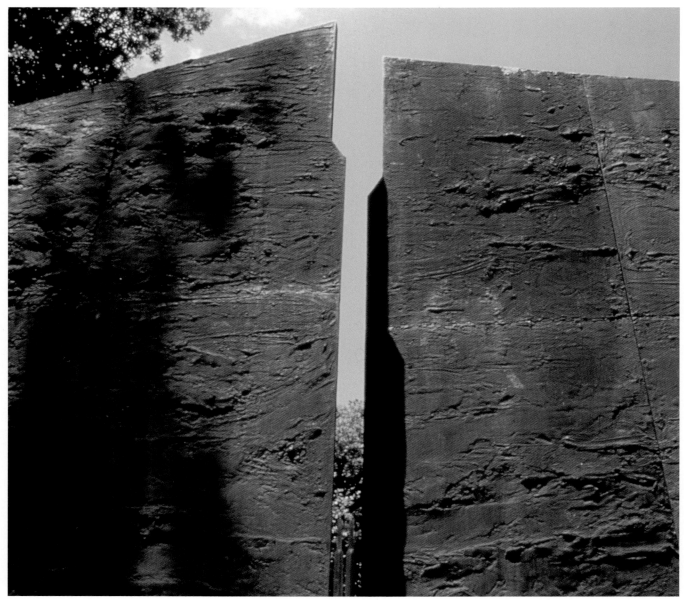

[3]

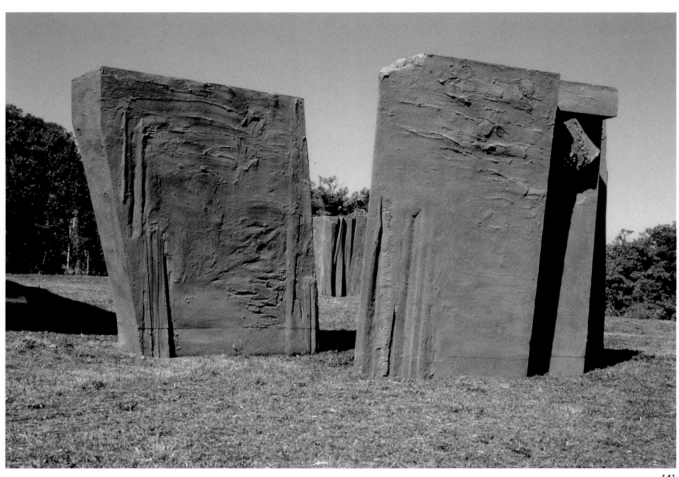

[4]

ARNALDO POMODORO

Born in Morciano di Romagna, Italy in 1926, Arnaldo Pomodoro has had his monumental sculpture installed in public sites throughout the world. After studying architecture, he began his career in set design and goldsmithing, later turning to the field of sculpture. He held his first exhibition with his brother Giò in 1954, and has since exhibited his work in more than one hundred solo shows.

Pomodoro is most widely known for his highly polished bronze columns and spheres. They contain splits, cracks, and fissures that reveal darkly patinated interiors. The outermost surfaces of these geometric forms are smooth and highly reflective, leaving deeply recessed, crusty cores. His approach to materials and form results in sculpture that simultaneously elicits a sense of archaic stele and machine-like objects of the world to come.

Pomodoro's sculpture is represented in over 120 public collections such as The Hakone Open-Air Museum, Tokyo, Japan; the City of Seoul, Olympic Park, Seoul, South Korea; and the Museum of Modern Art, New York, New York.

Wingbeat–Homage to Boccioni [1]
bronze
12' 6" x 13' x 18' (13.8 m x 4 m x 5.5 m)
Water and Power Building, Los Angeles,
 California
photo: Carlo Orsi

Sphere within a Sphere [2]
bronze
Diameter: 10' 9" (3.3 m)
United Nations Headquarters, New York,
 New York
photo: Steve Williams

Lance of Light [3]
Cor-ten steel, stainless steel
height: 98' 6" (30 m)
Terni, Corso del Popolo, Italy

Papyrus [4]
bronze, cement, Cor-ten steel
first element, 33' (10.1 m) high x 13' (4 m)
 wide; second element, 13' (4 m) high x 13'
 (4 m) wide; third element, 19' 6" (5.9 m)
 high x 13' (4 m) wide
Post Office Square, Darmstadt, Germany
photo: Thomas Eicken

[1]

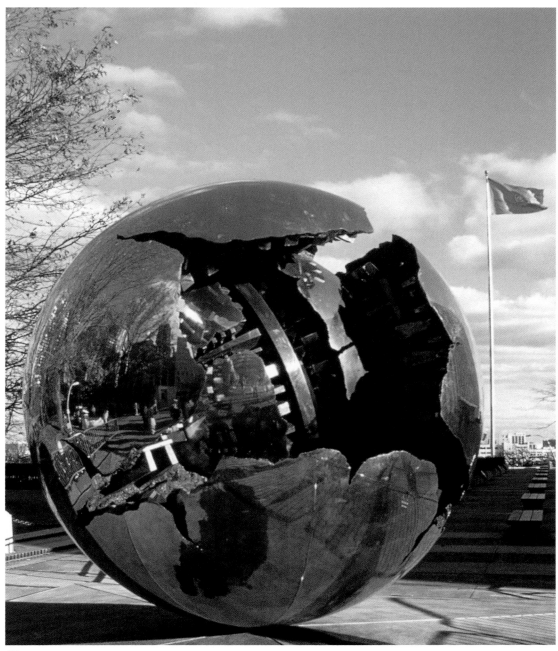

[2]

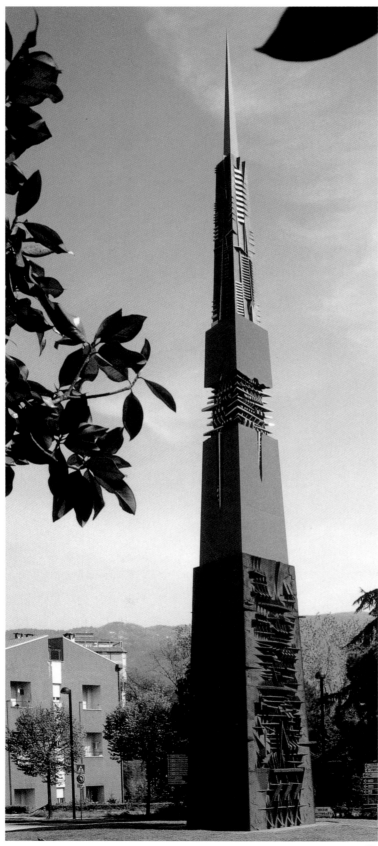

[3]

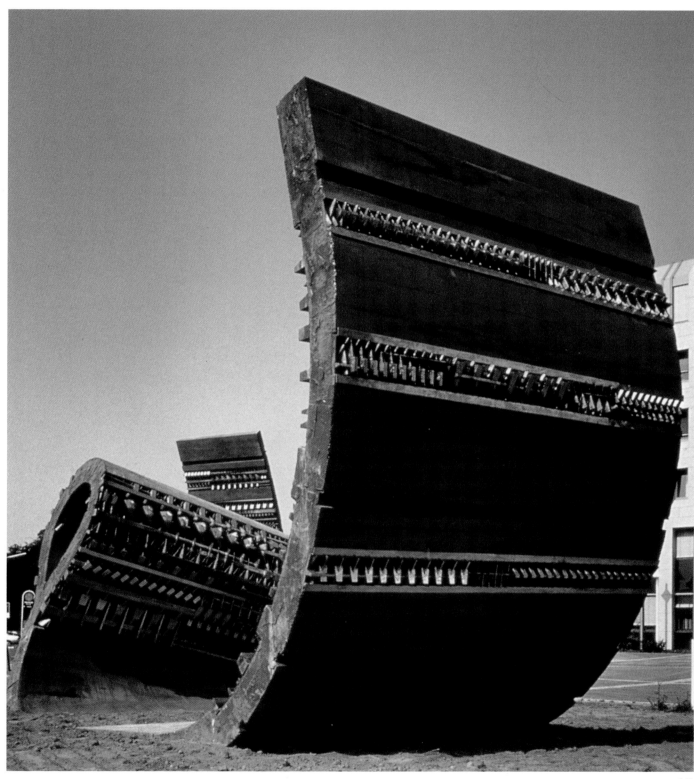

[4]

ALAN SONFIST

Alan Sonfist gained prominence in 1965 by creating *Time Landscape,* a recreation of a pre-colonial forest, in New York City. The idea of the urban forest and how it contributes to the fabric of the city has become a subject of great interest for both artists and landscape architects. Incorporating concepts of a site's natural and cultural histories, Sonfist has created landscape sculptures in Italy, Germany, Finland, and the United States. His work has ranged from a 1978 retrospective exhibition at the National Collection of Fine Arts in Washington, D.C., where he created an interior landscape referring to the history of the building, to a 1996 work, a seven-mile nature and sculpture trail in Palm Springs, California.

Born in New York City in 1946, Sonfist was invited by the French government to create a series of parks for a new section of Paris. The artist's primary interest is that of man's interaction with and preservation of the environment.

Natural/Cultural Landscape of Tampa,
detail: **Mural** [1]
historical bricks, earth, concrete
100' x 25' (30.5 m x 7.6 m)
Tampa, Florida
Mural detailing Florida's transition from forests
 to skyscrapers

Growing Protectors [2]
tree, earth, stainless-steel missile
16' x 8' x 5' (4.9 m x 2.4 m x 1.5 m)
Montreal, Canada
Missile flowering open to reveal a forest

Natural/Cultural Landscape of Tampa,
detail: **Living Column** [3]
concrete, water system, indigenous plants
15' x 4' x 4' (4.6 m x 1.2 m x 1.2 m)
Tampa, Florida
A juxtaposition of natural and cultural history

Oak Leaf Labyrinth [4]
stones, 1,001 endangered oak seedlings
1 acre (.40 hectares)
Denmark
A labyrinth of endangered oaks protected by a
 stone ship

[1]

[2]

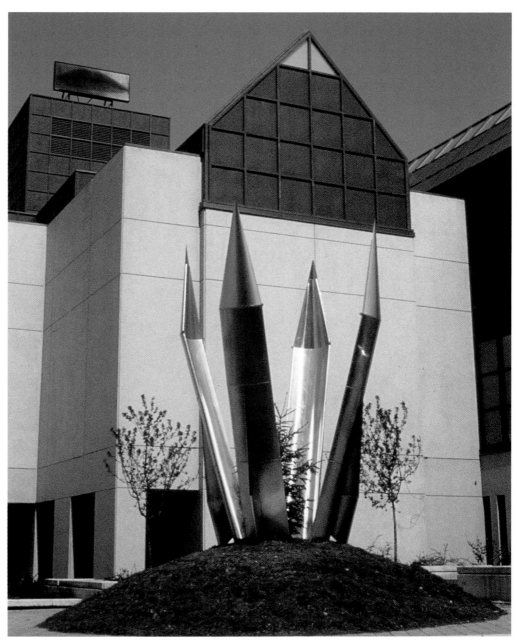

[2]

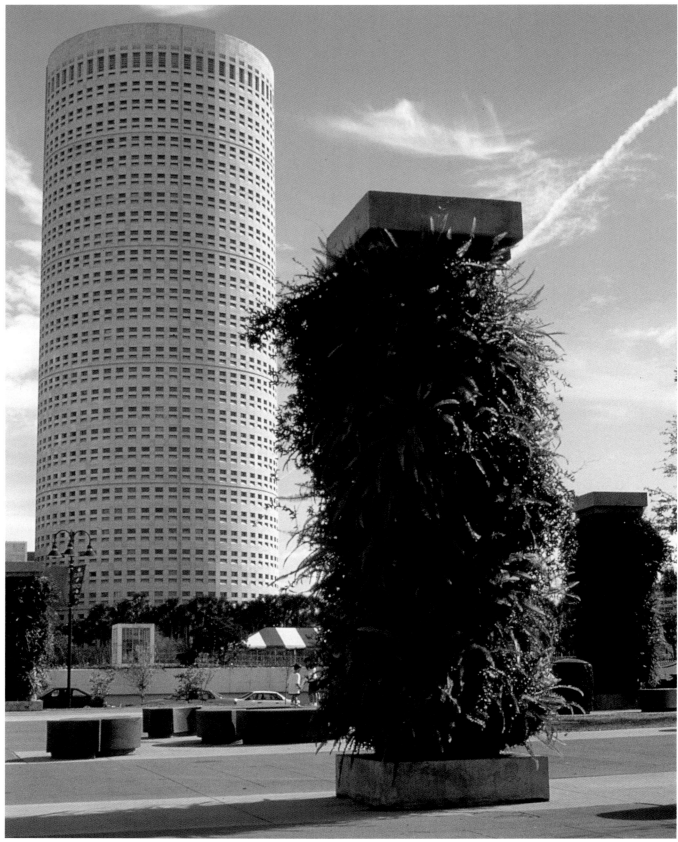

[3]

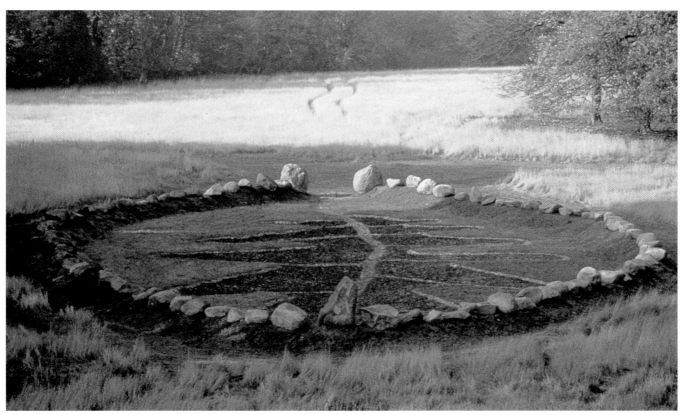

[4]

MICHAEL STEINER

By welding together both found and constructed steel shapes, Michael Steiner creates sculptures that bring to mind drawing in three-dimensional space. His technique allows him to work openly, building articulated forms that permit the viewer to look at both the interior and exterior of the sculpture simultaneously. Line, edge, shape, and plane are components he both utilizes and examines in composing his sculpture. Although very deliberately composed of rigid, weighty materials, Steiner's sculpture has a sense of fluidity, movement, and grace. Frequently his works in steel are later cast in bronze and given further refinements of surface and color.

Steiner has been contributing to the field of contemporary abstract sculpture for over thirty years. Born in New York City in 1945, he has participated in almost sixty one-person exhibitions and many group shows. Among the public collections containing his work are the Centre Georges Pompidou, Beauborg, Paris; the Hirshhorn Museum and Sculpture Garden, Washington, D.C.; and the Kunsthalle, Bielefeld, Germany.

The Bather [1]
bronze
9' 5" x 4' x 5' 3" (2.9 m x 1.2 m x 1.6 m)
Collection Phyllis and Jerome Lyle Rappaport, Newark,
 New Jersey
Courtesy Salander-O'Reilly Galleries, New York

Isabel [2]
steel for bronze cast
6' 4" x 5' 1" x 3' 2" (1.9 m x 1.5 m x .9 m)
Courtesy Salander-O'Reilly Galleries, New York

La Terrasse À Sainte-Adresse [3]
painted steel
4' 2" x 13' x 8' 5" (1.2 m x 4 m x 2.6 m)
Collection Gerald Piltzer, Paris, France
Courtesy Salander-O'Reilly Galleries, New York

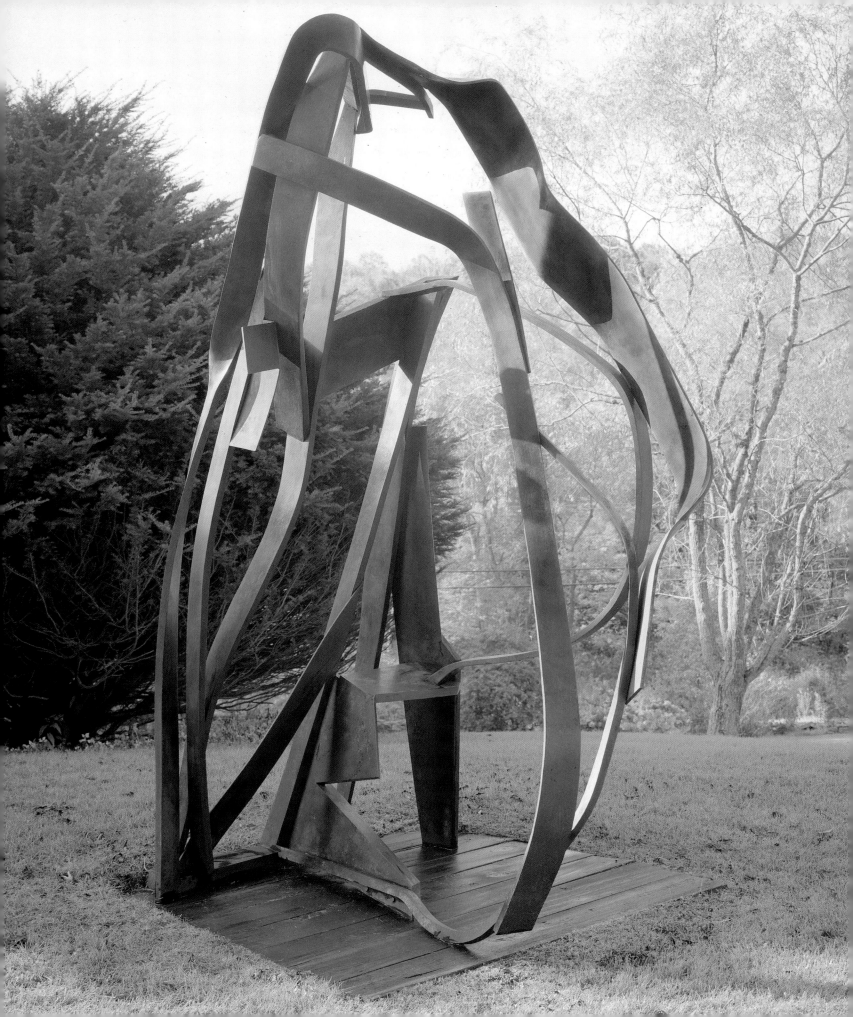

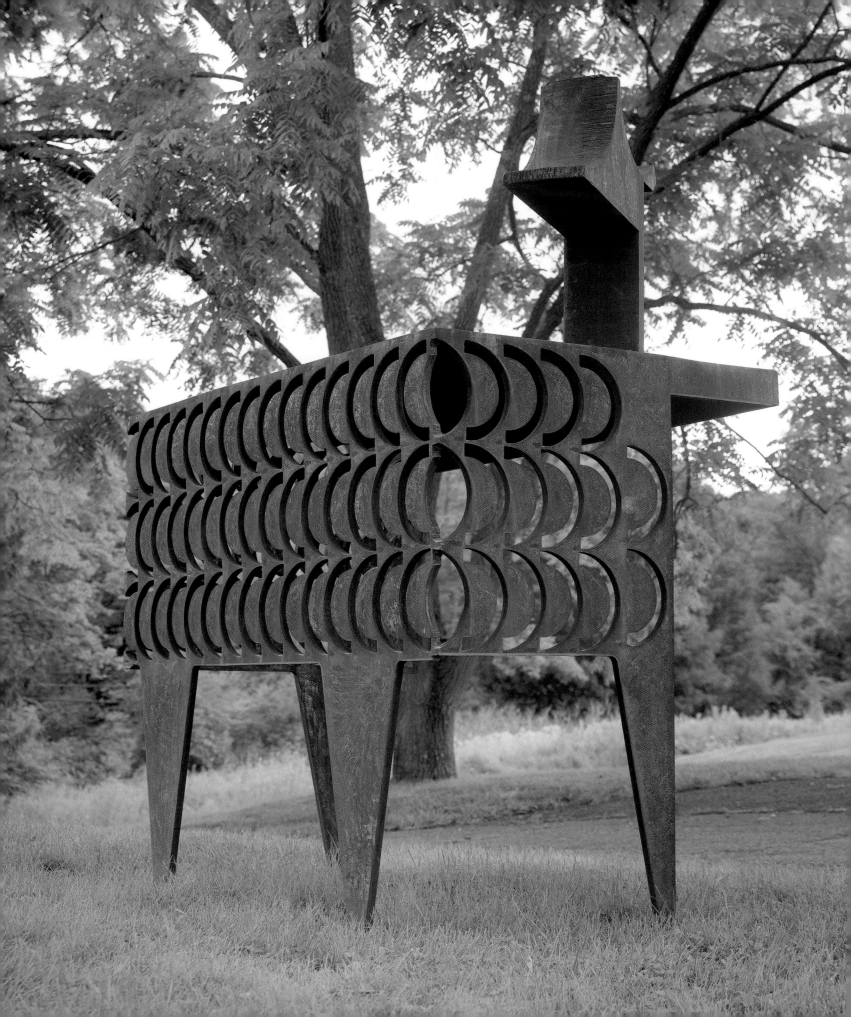

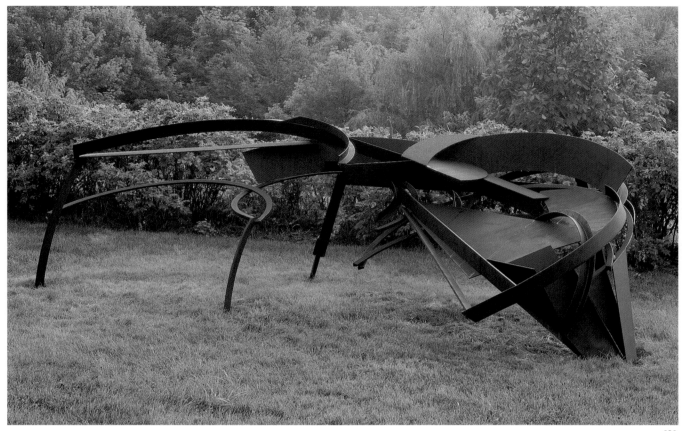

[3]

STRONG-CUEVAS

"With telescope eyes looking out to the universe, my work suggests space exploration, while the heads with double or more profiles suggest the complementarity of opposites, of psychological divisions, united in the unity of consciousness. Communication through space and time is what I seek to express, linking the ideas of the past with those of the future. The human face is the symbol I use . . . "

Strong-Cuevas

The sculptural language of Elizabeth Strong-Cuevas originates from the basic form of the human head. Whether simplified through the use of contours and profiles, or by the reduction of details in the case of the monumental works, Strong-Cuevas' abstract faces symbolize a universal human condition throughout time. References can be made to ancient cultures, such as the stone heads of Easter Island. However, just as easily, through the use of stylized forms and materials with modern characteristics such as aluminum and steel, they allude to the future.

Strong-Cuevas has been exhibiting for thirty years, primarily in the northeast United States. She has been represented in numerous solo exhibitions in New York, and her sculpture may be found in permanent collections at the Guild Hall Museum, East Hampton, New York; the Heckscher Museum, Huntington, New York; and Grounds For Sculpture, Hamilton, New Jersey.

Arch II, Set II [1]
fabricated, brushed aluminum
12' x 11' x 13' (3.7 m x 3.4 m x 4 m)
Shidoni, Tesuque, New Mexico
photo: Strong-Cuevas

Look Twice [2]
stainless steel, (mobile)
8' 6" x 5' 6" x 5' (2.6 m x 1.7 m x 1.5 m)
Amangasset, New York
photo: Renate Pfliederer

Five Elements [3]
stainless steel
8' x 9' x 5' (2.4 m x 2.7 m x 1.5 m)
Amangasset, New York
photo: Renate Pfliederer

Arch III, detail [4]
bronze with dark-brown patina
10' x 5' x 3' (3 m x 1.5 m x .9 m)
Amangasset, New York
photo: Joseph Mehling

[1]

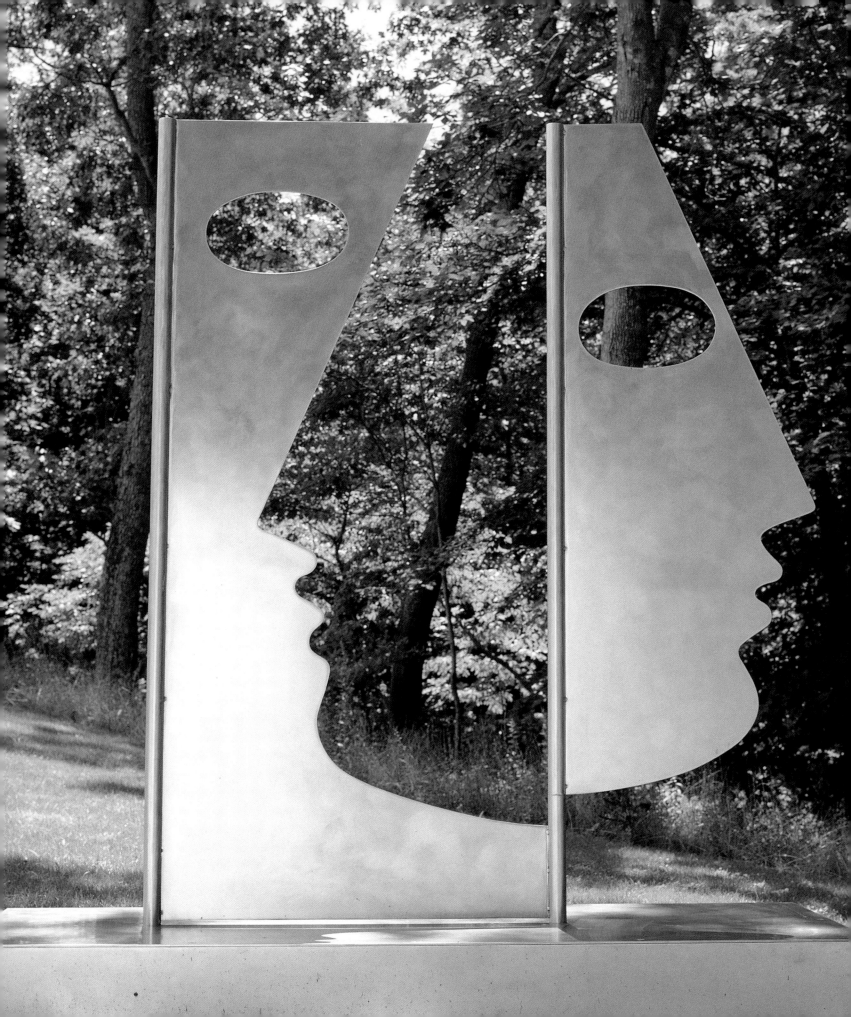

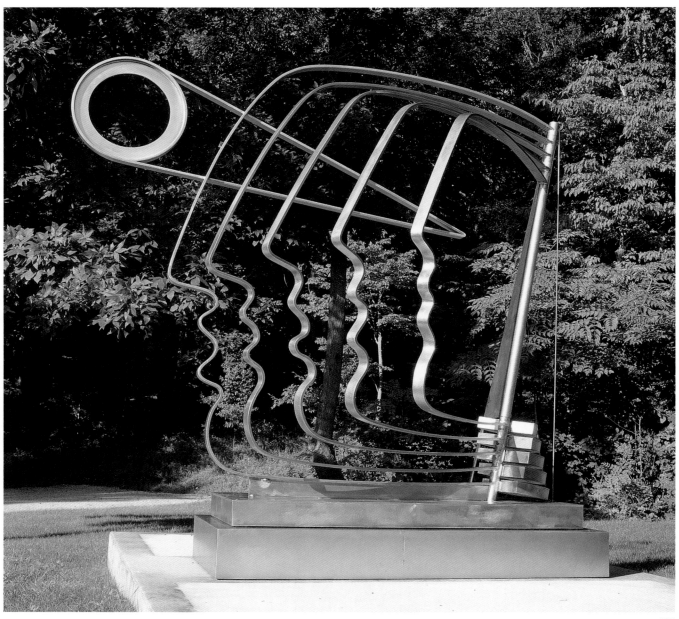

[3]

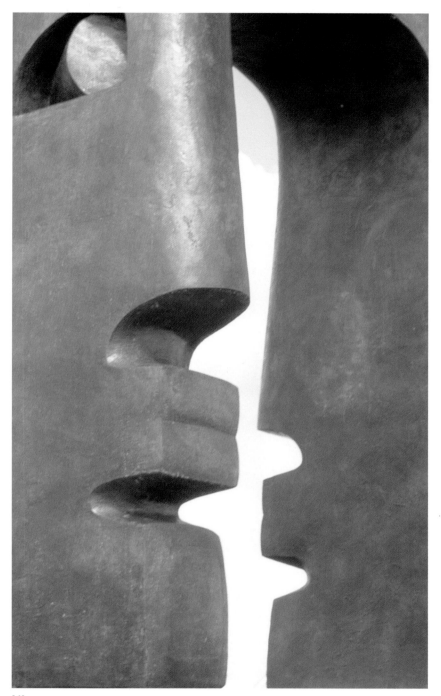

[4]

ATHENA TACHA

Born in Greece, Athena Tacha received an M.A. in sculpture from the Academy of Fine Arts, Athens, an M.A. in art history from Oberlin College, Ohio, and a doctorate in aesthetics from the Sorbonne University in Paris. She has worked as a curator of modern art and has published two books and numerous articles on Rodin, Brancusi, and other twentieth-century sculptors. Since 1973 she has been professor of sculpture at Oberlin College.

One of the first artists to develop site-specific sculpture in the early 1970s, Tacha has won nearly fifty competitions for permanent, public art, of which over thirty have been executed throughout the United States. These works may be found in Ohio, Oklahoma, Arizona, Alaska, New York, Virginia, Florida, and an entire city-block park in downtown Philadelphia. She has had four solo exhibitions in New York, and has exhibited in many group shows throughout the world, including the Venice Biennale.

In 1989, Athena Tacha had a retrospective exhibition of her sculpture, drawings, and conceptual photographic works at the High Museum of Art in Atlanta, Georgia. The same year she held an exhibition of over fifty sculptures and drawings, and two large installations at the Cleveland Center for Contemporary Art.

Green Acres [1]
brick, green slate, plates, photo sandblasting
5' x 80' x 90' (1.5 m x 24.4 m x 27.4 m)
Department of Environmental Protection,
 Trenton, New Jersey
photo: Richard E. Spear

Merging [2]
red and gray granite, waterfalls
7' x 65' x 72' (2.1 m x 19.8 m x 21.9 m)
Case Western Reserve University, Cleveland,
 Ohio
photo: Bruce Kiefer

Merging, detail [3]

[1]

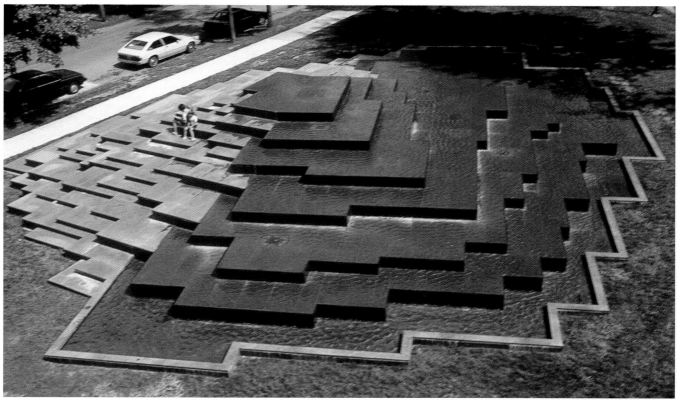

[2]

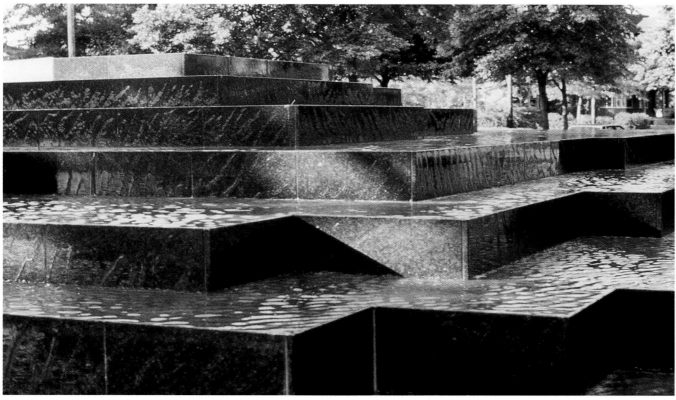

[3]

TOSHIKO TAKAEZU

Toshiko Takaezu is known as a contemporary master in the field of ceramics. She has been instrumental in moving ceramics beyond its traditional role, into the world of sculpture. Her outdoor works utilize the medium of cast bronze. These bronze forms have evolved from her clay vessels into closed, towering objects without any indication of functional use. Takaezu's multicolored patinas hearken back to her use of combinations of glaze colors in her clay work. The marks of the pottery wheel, and of the process of hand building, are still evident in the bronzes.

Born in Pepeekeo, Hawaii, in 1922, Toshiko Takaezu began her lengthy teaching career at the Cranbrook Academy of Art in Michigan, and completed it at Princeton University, New Jersey. She has received numerous grants and awards, most notably an Honorary Doctorate from Lewis and Clark College in Portland, Oregon. Since 1955 this artist has held more than forty-five one-person exhibitions, and is represented in the permanent collections of many noteworthy museums: the Metropolitan Museum of Art, New York, New York; the National Museum, Bangkok, Thailand; the Everson Museum, Syracuse, New York; and the Smithsonian Institution, Washington, D.C.

Tree-Man Forest [1]
cast bronze, five elements
7' 9" x 9' 6" x 9' 6" (2.4 m x .2 m x .2 m)
Bristol-Myers Squibb Company, Princeton,
 New Jersey
Courtesy Creative Arts Management, Princeton,
 New Jersey
photo: Ricardo Barros

Three Graces [2]
cast bronze, three elements
5' 10" x 1' 11" x 1' 11" (1.8 m x .5 m x .5 m)
 each
Grounds For Sculpture, Hamilton, New Jersey
photo: Ricardo Barros

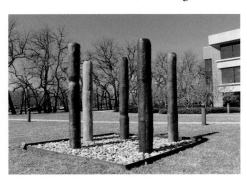

[1]

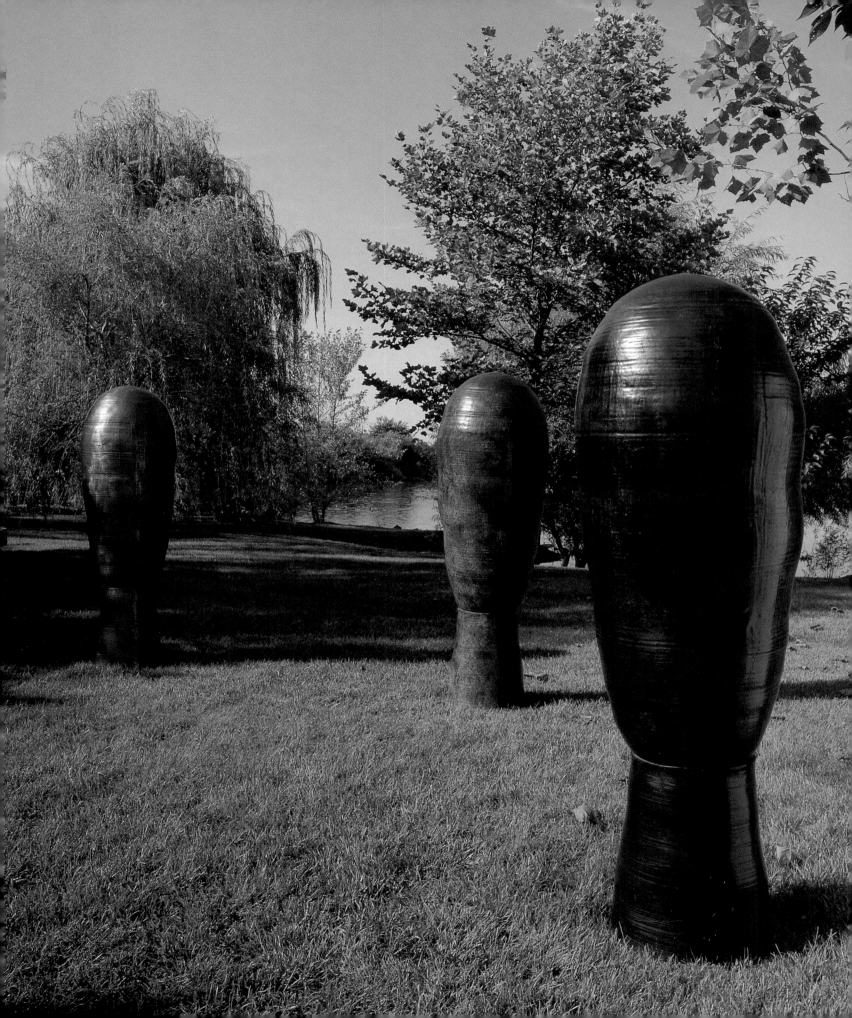

ANA THIEL

Ana Thiel has been working with glass as a sculptural medium for the past seventeen years. Her inspiration is derived from, "the ever-present wonder of nature, the wordless sounds of music, and the inner world that seeks expression through the three-dimensionality of sculpture . . . " Her sculptures are sometimes combined with water, and are usually placed in quiet garden spaces, " . . . to offer a space for growth, for harmony and for inner peace—a moment of respite amidst the tensions of today's way of life, and a reminder of the strength that we all possess within."

Thiel was born in Mexico City in 1958, and received a degree in industrial design from the Iberoamericana University. She has extensively studied glass blowing and casting techniques and since 1980 she has taught and lectured on the art of glass at universities and cultural institutions in Mexico, the United States, Europe, and Central and South America.

In 1993, Thiel was awarded a fellowship from the Mexican Council for the Arts. She has exhibited widely and her work can be found in the permanent collection of the Corning Museum of Glass, New York; Ebeltoft Glass Museum, Denmark; Lemberk Castle Museum, Czech Republic; and La Granja Royal Glassworks, Segovia, Spain.

Yearning [1]
cast glass, stone
5' 2" x 2' 3" x 1' (1.6 m x .7 m x .3 m)
National Institutes of Fine Arts, San Miguel de
 Allende, Guanajuato, Mexico
photo: Ramón Vinyes

Stardust [2]
cast glass, forged metal
7' 6" x 6' 5" x 1' 5" (2.3 m x 2 m x .5 m)
photo: Ana Thiel

Seed [3]
sand-cast and blown glass
8" x 11" x 11" (20 cm x 28 cm x 28 cm)
photo: Ana Thiel

[1]

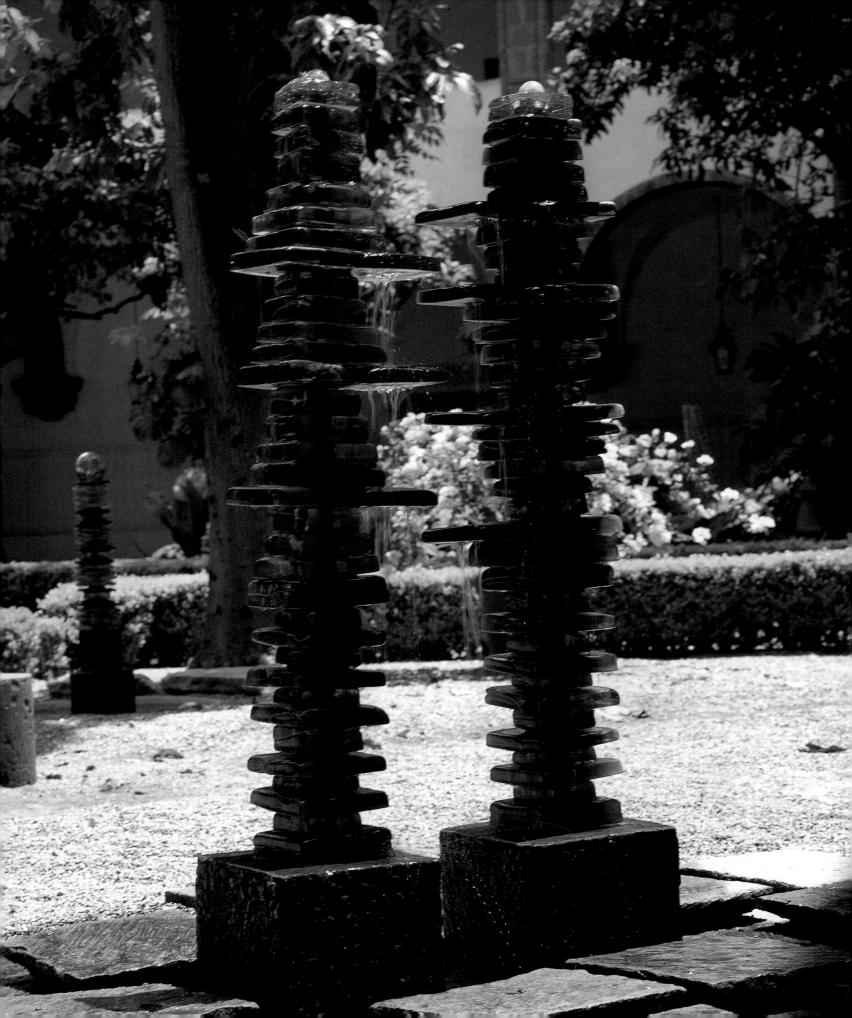

WILLIAM TUCKER

Born in Cairo, Egypt in 1935, William Tucker returned to England with his family in 1937. A leading member of the postwar school of British sculptors, Tucker moved to the United States in 1978. Previously known for open, geometric, planar constructions, in 1984 Tucker's work took a turn toward roughly modeled, bulky volumes. These muscular sculptures are made out of masses of plaster expressively formed into gestural lumps that are later cast in bronze. Taking traditional modeling techniques to the extreme, Tucker pushes and pulls the plaster into shape. His work suggests the possibility for the emergence of primordial figures from their unfinished mass. Although at times they can seem ambiguous, subtle references are made to body fragments such as torsos, limbs, and joints.

Since 1969, William Tucker has held ten one-person museum exhibitions and more than thirty-seven solo gallery exhibitions around the world. His sculpture can be found at the Hakone Open Air Museum, Japan; Victoria and Albert Museum, London, England; Rijksmuseum Kroller-Muller, Otterlo, Holland; and the Solomon R. Guggenheim Museum, New York, New York.

The Rim [1]
mild steel
diameter: 14' (4.3 m)
Installation at Laumeier Sculpture Park,
 St. Louis, Missouri

Okeanos [2]
bronze
12' 7" x 9' 7" x 12' 7" (3.8 m x 2.9 m x 3.8 m)
Installed at Scripps Clinic and Research
 Foundation, La Jolla, California

[1]

[2]

ISAAC WITKIN

Isaac Witkin has been creating large-scale, outdoor sculpture for four decades. Previously known for his steel constructions, in the late 1970s he began to explore the medium of bronze. He started with experimental foundry techniques, pouring the molten metal directly onto sand. The cooled and hardened metal forms inspired the more finished and refined shapes of his subsequent work. The medium and technique of casting bronze has allowed Witkin to develop a new sculptural vocabulary.

Born in 1936 in Johannesburg, South Africa, Witkin emigrated to England where he studied under Anthony Caro and served as an assistant to Henry Moore. Arriving in the United States in 1965, he taught for many years at Bennington College in Vermont. Sculptures by Witkin can be found in the permanent collections of museums and art institutions around the world: the Caloust Gulbenkian Foundation, London; the National Museum of American Art, Washington, D.C.; and the Israel Museum, Billy Rose Garden, Jerusalem, to name a few. Witkin has had numerous one-person shows and has been included in many group exhibitions.

Hawthorne Tree II [1]
cast bronze
7' 6" x 7' 3" x 4' 8" (2.3 m x 2.2 m x 1.4 m)
Grounds For Sculpture, Hamilton, New Jersey
photo: Jerry L. Thompson

Earth, Water, and Sky [2]
cast bronze
16' 6" x 7' 9" x 7' 6" (5 m x 2.4 m x 2.3 m)
Department of Transportation, Ewing,
 New Jersey
photo: Jerry L. Thompson

The Bathers [3]
cast bronze
8' 9" x 5' 3" x 3' 1" (2.7 m x 1.6 m x .9 m)
Grounds For Sculpture, Hamilton, New Jersey
photo: Jerry L. Thompson

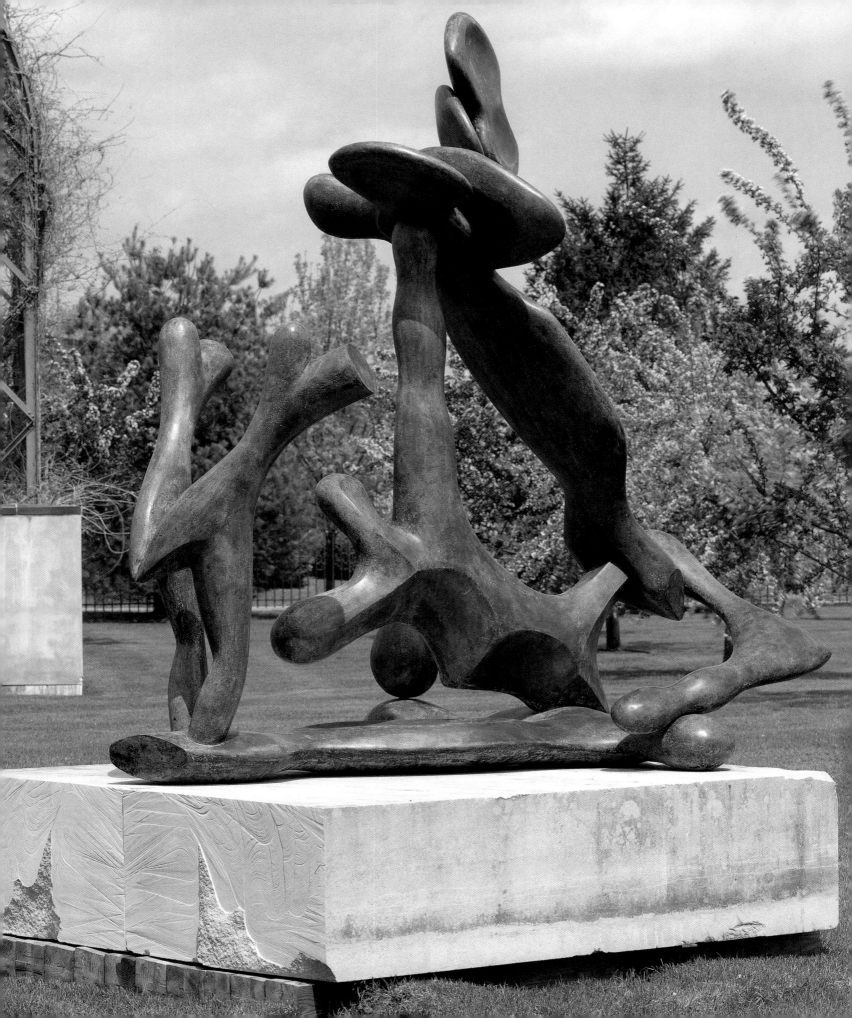

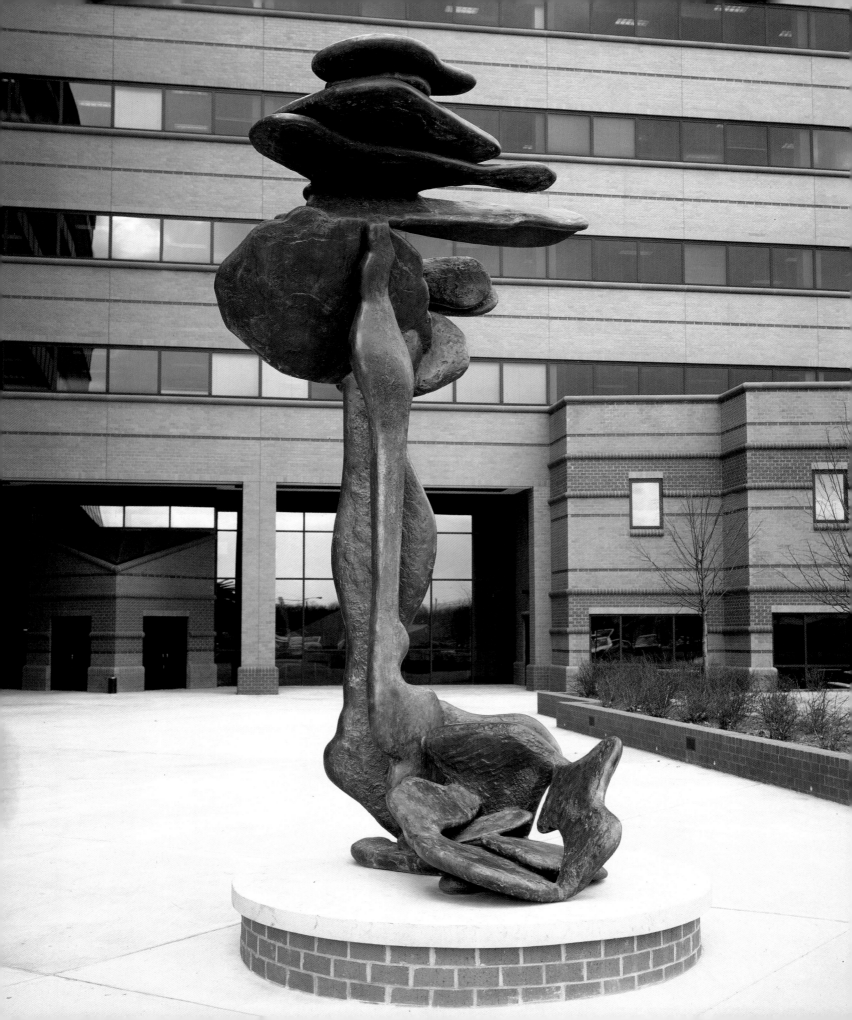

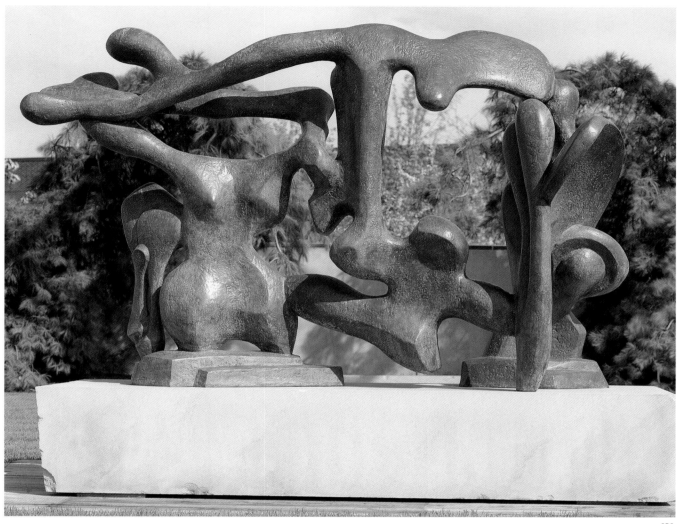

DIRECTORY OF ARTISTS AND GALLERIES

MAGDALENA ABAKANOWICZ
c/o Marlborough Gallery
40 West 57th Street
New York, NY 10019

BRUCE BEASLEY
322 Lewis Street
Oakland, CA 94607-1414

JONATHAN BOROFSKY
c/o Paula Cooper Gallery
534 West 21st Street
New York, NY 10011

FERNANDO BOTERO
c/o Marlborough Gallery
40 West 57th Street
New York, NY 10019

DEBORAH BUTTERFIELD
c/o Edward Thorp Gallery
103 Prince Street, 2nd floor
New York, NY 10012

MURIEL CASTANIS
444 6th Street
New York, NY 10011

CHRISTO AND JEANNE-CLAUDE
48 Howard Street
New York, NY 10013

MICHELE OKA DONER
94 Mercer Street
New York, NY 10013

MING FAY
830 Broadway, 9th Floor
New York, NY 10003

AUDREY FLACK
110 Riverside Drive, Apt 10A
New York, NY 10024

MARY FRANK
c/o DC Moore Gallery
724 5th Avenue
New York, NY 10019

VIOLA FREY
c/o Nancy Hoffman Gallery
429 West Broadway
New York, NY 10012

TETSUO HARADA
4, rue Pihet
75011 Paris, France

LUIS JIMÉNEZ
P.O. Box 7
Hondo, NM 88336

J. SEWARD JOHNSON, JR.
c/o Sculpture Placement, Ltd.
1636 Connecticut Avenue NW, Suite 500
Washington, D.C. 20009-1043

ANISH KAPOOR
c/o Barbara Gladstone Gallery
99 Greene Street
New York, NY 10012

LILA KATZEN
459 Washington Street
New York, NY 10013

MEL KENDRICK
134 Duane Street
New York, NY 10013

WILLIAM KING
21 Saddle Lane
East Hampton, NY 11937

GRACE KNOWLTON
c/o Hirschl and Adler Modern
21 East 70th Street, 2nd floor
New York, NY 10021

ALEXANDER LIBERMAN
c/o André Emmerich Gallery
41 East 57th Street
New York, NY 10022

CLEMENT MEADMORE
c/o André Emmerich Gallery
41 East 57th Street
New York, NY 10022

MARY MISS
P.O. Box 304
Canal Street Station
New York, NY 10013

JESÚS BAUTISTA MOROLES
408 West 6th Street
Rockport, TX 78382

ROBERT MURRAY
345 Lambornton Road
West Grove, PA 19390

DENNIS OPPENHEIM
c/o Joseph Helman Gallery
20 West 57th Street
New York, NY 10019

OTOM OTTERNESS
c/o Marlborough Gallery
40 West 57th Street
New York, NY 10019

BEVERLY PEPPER
84 Thomas Street
New York, NY 10013

ARNOLDO POMODORO
c/o Marlborough Gallery
40 West 57th Street
New York, NY 10019

ALAN SONFIST
205 Mulberry Street
New York, NY 10012

MICHAEL STEINER
c/o Salander-O'Reilly Galleries
20 East 79th Street
New York, NY 10021

STRONG-CUEVAS
211 Central Park West
New York, NY 10024

ATHENA TACHA
291 Forest Street
Oberlin, OH 44074

TOSHIKO TAKAEZU
P.O. Box 422
Quakertown, NJ 08868

ANA THIEL
Colegio Militar, No. 1
San Miguel de Allende
37710 Gto., Mexico

WILLIAM TUCKER
c/o McKee Gallery
745 Fifth Avenue
New York, NY 10151

ISAAC WITKIN
137 Scrapetown Road
Pemberton, NJ 08068